River of No Return

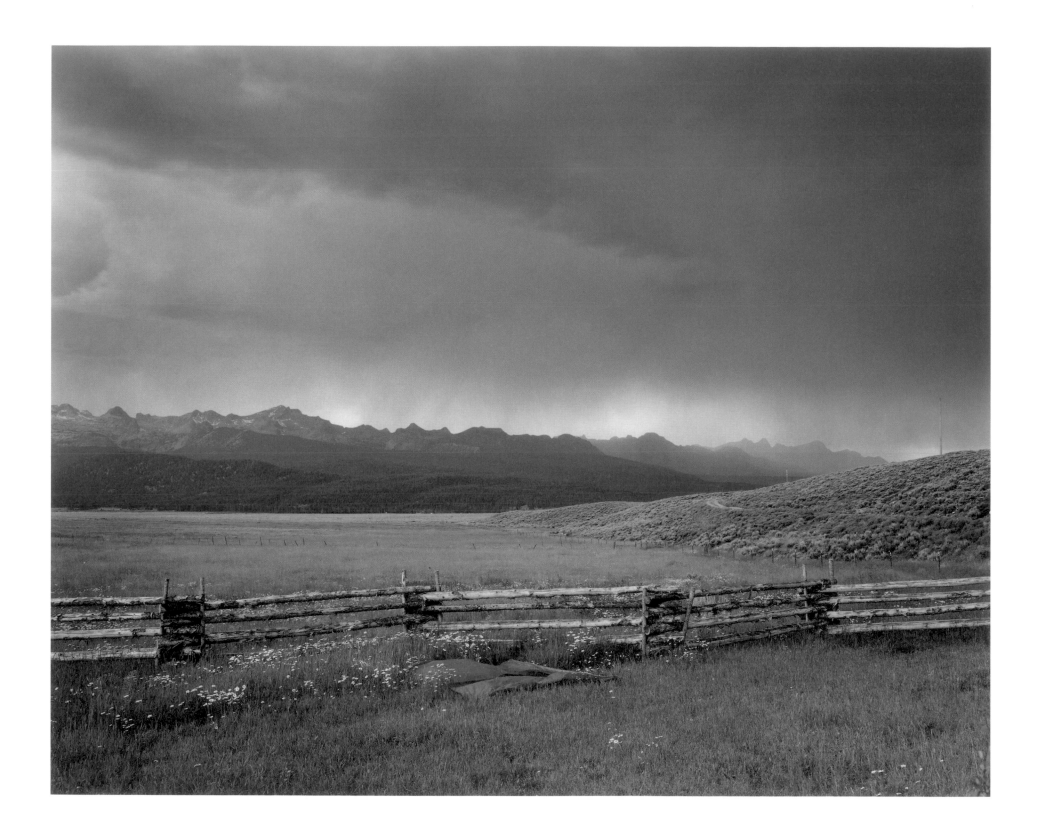

River of No Return Photographs by Laura McPhee

FOREWORD BY ROBERT HASS
With an essay by Joanne Lukitsh and an interview by Dabney Hailey

Yale University Press, New Haven and London

For Isobel and For Mark

Imagine a Carthage sown with salt, and all the sowers gone, and the seeds lain however long in the earth, till there rose finally in vegetable profusion leaves and trees of rime and brine. What flowering would there be in such a garden? Light would force each salt calyx to open in prisms, and to fruit heavily with bright globes of water—peaches and grapes are little more than that, and where the world was salt there would be greater need of slaking. For need can blossom into all the compensations it requires. To crave and to have are as like as a thing and its shadow. For when does a berry break upon the tongue as sweetly as when one longs to taste it, and when is the taste refracted into so many hues and savors of ripeness and earth, and when do our senses know any thing so utterly as when we lack it? And here again is a foreshadowing—the world will be made whole. For to wish for a hand on one's hair is all but to feel it. So whatever we may lose, very craving gives it back to us again. Though we dream and hardly know it, longing, like an angel, fosters us, smooths our hair, and brings us wild strawberries.

From *Housekeeping*, by Marilynne Robinson

Foreword

The name first. The "River of No Return" is a nickname for the Salmon River, which originates in the Rockies and flows through central Idaho, where it joins the Snake River, which joins the Columbia in eastern Washington. The Salmon River got its other name from the swiftness of its current. It drops as streams out of the mountains into the Sawtooth Valley, which is the subject of many of these photographs. The Nez Perce have lived along the Salmon River and so have a Shoshone people. Lewis and Clark passed north of the valley, and fur hunters must have passed through after them, but the valley was settled by European stock only when the prospectors arrived in 1867. They brought names with them: Lucky Boy, Sunbeam, Custer Mill. They mined for gold and silver and quartz. In 1879 the mine at Custer Mill took out a million dollars in gold in its first year of operation, and five to eight million before it closed in 1888. Lucky Boy closed in 1904 and Sunbeam in 1911. The area was by then known as Custer County, and it had turned to farming and ranching. (You probably do not get more American or more mythic than to locate yourself at Fourth of July Creek Ranch in Custer County with the Sawtooth Mountains in the distance and the River of No Return flowing through your pastures.) The Silas Mason Company of Shreveport, Louisiana, bought up all the old mining properties in 1940, brought in a huge gold dredge to work the river, and churned out of it an estimated 80 percent of the remaining gold before closing down in 1952. The Nez Perce called it the River of No Return because it was easy to get down and almost impossible to get back up. Rivers, of course, are metaphors for time—and for nature, and for history, all of which are irreversible processes.

Laura McPhee made these remarkable photographs over several years on successive visits to the valley. This book of seventy-two images is itself a work of art: it accumulates meanings through echo, repetition, statement and counter-statement, digression, and return. I didn't feel this, paging through the photographs the first time, taking my bearings among the images. On the second or third time through it began to dawn on me what Laura McPhee was up to, to see that *River of No Return* is organized like a long poem or a piece of music, that it is, as well as a stunning look at an actual place, a meditation on rivers, nature, history, the history of landscape photography, of the American West and of the idea of the American West. And—while I am piling theme on theme—the nature of fact and the nature of myth, and how we hold the world in our hands.

It is a book that tends to reverse the roles of fact and myth, and this probably has as much to do with the recent history of central Idaho and the Sawtooth Valley as it does with the history of photography. The Silas Mason Company pulled out of Custer County in 1952, and it isn't too hard to imagine the condition in which the operation left land and river. The country, in those years, was busy fighting the Cold War and constructing the postwar system of national highways, and must have left the valley to itself for a decade. In the war years and in the 1950s the country had returned to its pell-mell exploitation of its natural resources. It was a little schizophrenic about this, since this was also the period when the genre of the Western film flourished with its myth of unfettered freedom and wide open spaces, when the most popular form of landscape photography was the cinematography

in the films of John Ford. The country was celebrating an imagined past it also seemed that it could not erase fast enough.

Then, in the early 1960s, for a startling few years the country began to take account of the damage that had been done in the headlong development of the previous two centuries, and to do something about it. One form this took was the Wilderness Act of 1964, which set aside nine million acres of public land that were deemed to be "untrammeled by man" to be managed "for the use and enjoyment of the American people in such manner as will leave them unimpaired for future use and enjoyment as wilderness." No roads were to be built on this land, no structures were to be erected, and motor vehicles were to be excluded. The Wilderness Act was followed by the Wild and Scenic Rivers Act in 1968, which specified that the Middle Fork of the Salmon River, along with several other rivers or sections of rivers, be kept "in free-flowing condition, and that they and their immediate environments shall be protected for the benefit and enjoyment of present and future generations." In 1980 the River of No Return Wilderness was established, setting aside 2.3 million acres of land, the largest protected wilderness area in the continental United States. This signaled a shift, not in the wilderness of the place of unfettered freedom but in a place managed by a federal bureaucracy for some notion of a common good. This is the place that Laura McPhee came into and began to look at.

Thinking about her experience, I found myself returning to the second photograph in the book, *One Car Passing, Valley Road, Sawtooth Valley, Idaho, 2003*. It is difficult to think about photographs of the American West without thinking of the history of photographs of the American West, but I didn't think about much of anything looking at that image. I was in the car raising that dust and in the distance watching it, the sense of space, the hazy mountains in the distance, a hawk's distance, that dry high desert landscape, the time of year that raises that dust, the curious grandeur and poverty and toughness of the arid inland West. It's all there, and so is the elegant and orderly punctuation of those fence posts, which almost seem to be there to remind the viewer of Charles Olson's remark that the history of the West is the history of barbed wire. Above all, I loved and can make no particular account of that sudden swerve of the road and the car and the dust in the middle upper right of the image. Where is that pickup? Jeep? old

Chevy going? Somewhere. Going about its business in this astonishing and mysterious enactment of intention.

It is a wonderful image, odd and beautiful and witty and strange, and I found myself wondering just how acutely self-conscious this assignment, or opportunity, had made Laura McPhee. How could she not have in mind the work of Ansel Adams (and the cinematography of John Ford's cameramen) or, for that matter, of the great U.S. Geological Survey work of Timothy O'Sullivan, whose *Shoshone Canyon and Falls, Idaho, 1873* could not have been shot very far from the Sawtooth Valley? *One Car Passing* complicates this reading of her genealogy. The sense of movement created by the dust gives us the documentary glimpse. But the image with its series of horizontal zones is exquisitely composed. The horizontal line made by the three vertical fence posts doesn't just echo the line made by the road dust; the parallel makes them seem like two kinds of time—nineteenth-century time and twentieth-century time, and this makes the mountain range, hazy in the distance, seem like geological time presiding over both, and these various senses of location and movement in place speak somehow to the exactly rendered foreground of high desert sage. And the whole image of quick passage, therefore, stands still and has its say about wide spaces and mountains and sagebrush and the size of human will and, in my reading anyway, the comedy and melancholy of human endeavor. Even if what the viewer sees is a celebration of human energy and the beauty of the swerve, it is an enormously complicated and subtle image.

Subtlety, richness, complication seem to unfold in the sequencing of the opening set of images. The first image in the book, *Irrigator's Tarp Directing Water, Fourth of July Creek, Custer County, Idaho, 2004*, instructs us in how McPhee is going to use titles in this book, to give us information that the photos don't, to explain and locate in time and place what we are seeing. We would not know that the tarp was directing water if she hadn't told us. It would simply have been an odd, bright mark of human presence in the landscape. And the presence of the tarp reminds us that the fence also, which seems so entirely naturalized, is also a mark, an older one, of human presence. I believe this fence is constructed in the style that used to be called a "worm fence," as in Walt Whitman's evocation of it: "And mossy scabs of the worm fence, and heaped stones, and elder and mullen and

pokeweed." The tarp gives us the creek, which seems to parallel the fence, and the creek gives us the clouds by way of the water cycle, and the clouds give us that bright scattering of wildflowers, some kind of daisy, and the daisies give us the season—this is an early summer storm. And the blue of the tarp picks up on the blue of the mountains and the blue of the storm clouds. It is palpably, physically, early summer in the mountains, and this theme of human presence in the landscape (echoed in the little distant irregular sticks of another fence) is set out.

Then comes *One Car Passing* to restate the theme. And then we come to Mattie. Here she is *Mattie with a Plymouth Barred Rock Hen, Laverty Ranch, Custer County, Idaho, June, 2004.* And she looks to be another development of the theme, if because of her deadpan and her beauty, a slightly disconcerting one; this *Mattie* looks a bit like a 4-H Club photograph shot by Diane Arbus. A farm girl, a farm girl holding a hen, a Plymouth Barred Rock Hen. "One of the foundation breeds for the broiler industry in the 1920s," a poultrymen's Web site remarks, it was "developed in New England in the early 1800's from Dominiques, Black Javas, and Cochins probably," and first exhibited as a breed in 1869. All of which is to say that Mattie, stark against a black background, expressionless, cradling the foundation of the broiler industry of the 1920s in her arms, is not a figure yet for Mother Nature or Artemis, the young half-boy goddess of wild things. She is not yet a symbol of the need to nurture, or of the future, though, by the end of the book, in her repeated and haunting appearances she will become all these things, whether she is holding a Bourbon Red Turkey (bred in Kentucky from a Pennsylvanian stock of Buffs), or a robin's nest containing four blue eggs (while she wears an Isadora Duncanish eighth grade graduation dress), or, in the same dress, a very beautiful northern flicker, a wild bird this time, her arms and elbows mimicking the dead bird's wings.

The fourth image is a field of grass and sagebrush in the mist with the repeated emblem of the fence. The fifth, *Sorting Black Angus Cow/Calf Pairs, Morgan Williams Ranch, Custer County, Idaho, 2003*, explains the fences and gives us emphatically one kind of work in Custer County. Mattie then returns in the sixth image and announces that the matter-of-fact world of the farm and the myth world have been introduced to each other. *Rocks from Sawtooth National Forest*

for Landscaping in Sun Valley, Pettit Lake Road, Blaine County, Idaho, 2003, with its five great rocks and its unhitched trailer—a dust of snow on the mountains, so it must be October—to remind us again of how people continue to make a living in the National Forest, quarrying rock for the swank skiers' terraces of Sun Valley. And the photograph seems to reference, almost helplessly, or perhaps slyly, the great boulders among shafts of paradisal sunlight and clouds and mountains in Ansel Adams's *Mount Williamson, Sierra Nevada, from Manzanar, 1944*. To remind us once again of the argument being conducted and what seems a deep love of the history of her art that partly informs McPhee's art.

There are other thematic suites of photos in the book—the Mattie series; a mines and miners sequence that includes two photographs of old photographs left behind at the abandoned mines, one from a 1940s women's magazine and one from a 1970s *Penthouse*, to provide another kind of meditation on time and photography; there is a brief sequence of fences in different weathers that puts one in mind of Monet's haystacks; a sequence on river restoration ("the civil rights movement we need in the twenty-first century," Bruce Babbitt said) and the endangered sockeye salmon; the butchered elk sequence; a winter snow sequence; and a final meditation on fire. They make an amazingly rich story about people and land and creatures, the past and the future. Near the core of it is the life lived in this place: a girl's feet in a cool stream, a bored child in the front seat of a pickup on a hot day. Much of this sense of a present magically informed by history lies in the image of Mattie in her grandmother's wedding dress. The white billows of the dress resemble the billows of smoke from a mid-summer forest fire on the book's concluding pages. Attention, Simone Weil said, is prayer. There is an abundance of it here. *River of No Return* is a book to make you love the photograph and the book of photographs as an art form.

Robert Hass
Berkeley, California

Plates

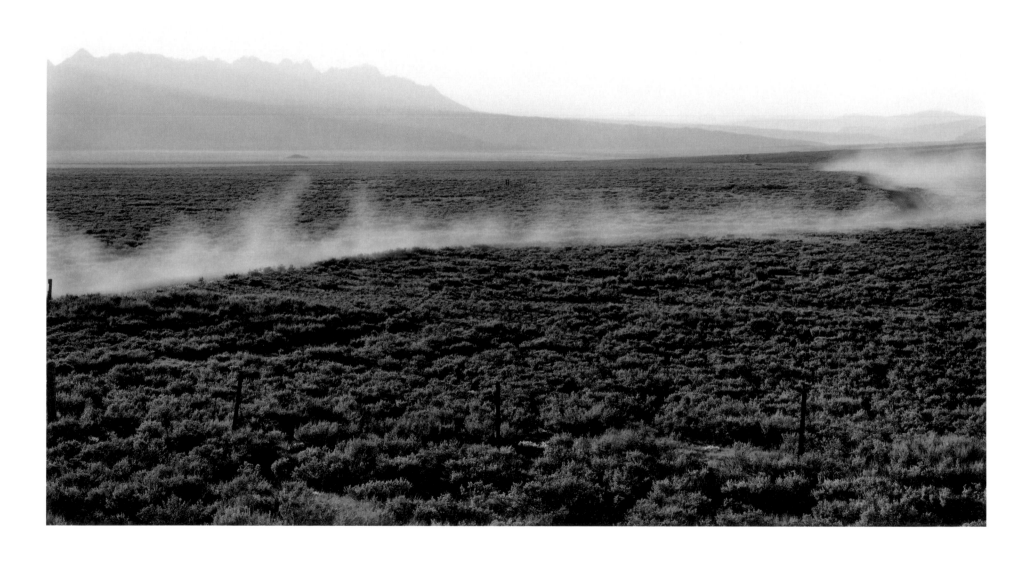

One Car Passing, Valley Road, Sawtooth Valley, Idaho, 2003

Mattie with a Plymouth Barred Rock Hen, Laverty Ranch, Custer County, Idaho, June, 2004

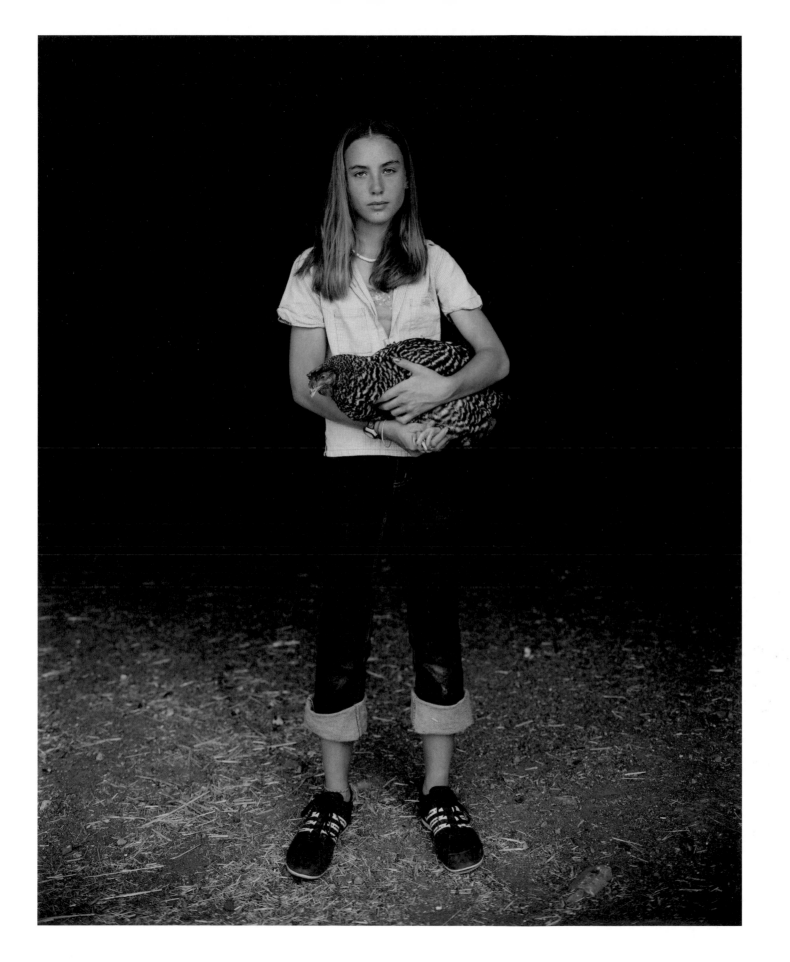

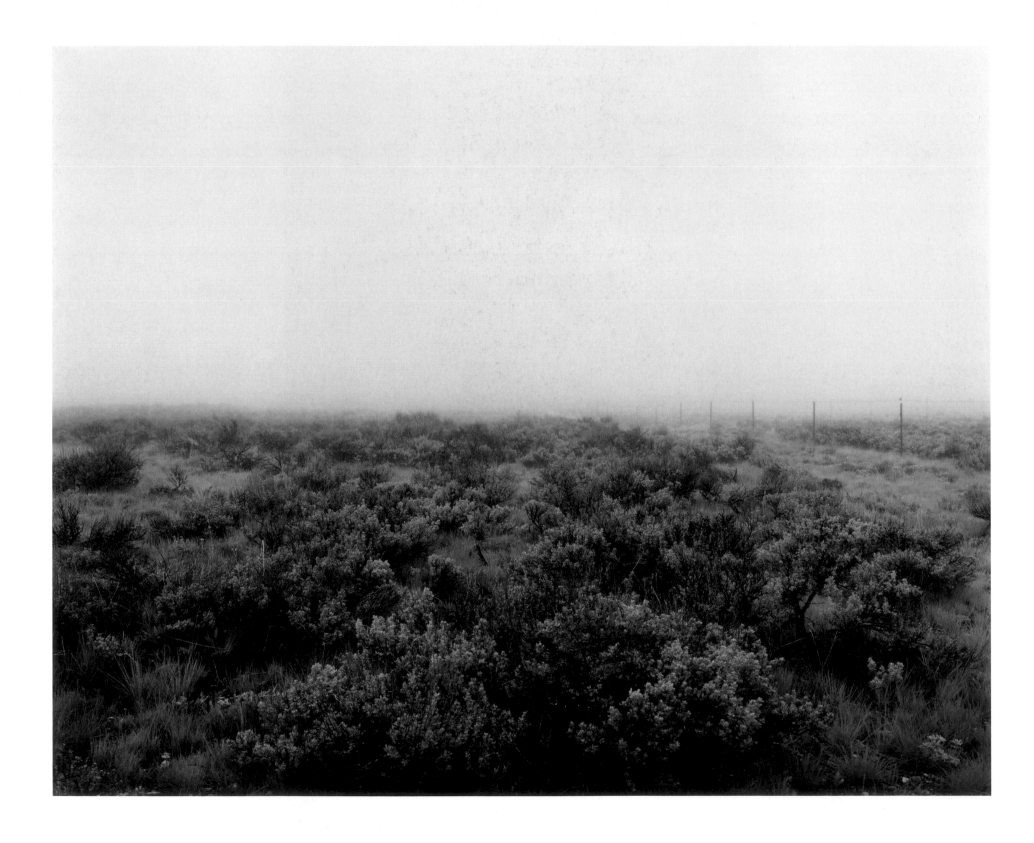

Sagebrush and Grass in an Irrigated Field, Fourth of July Creek Ranch, Custer County, Idaho, 2005

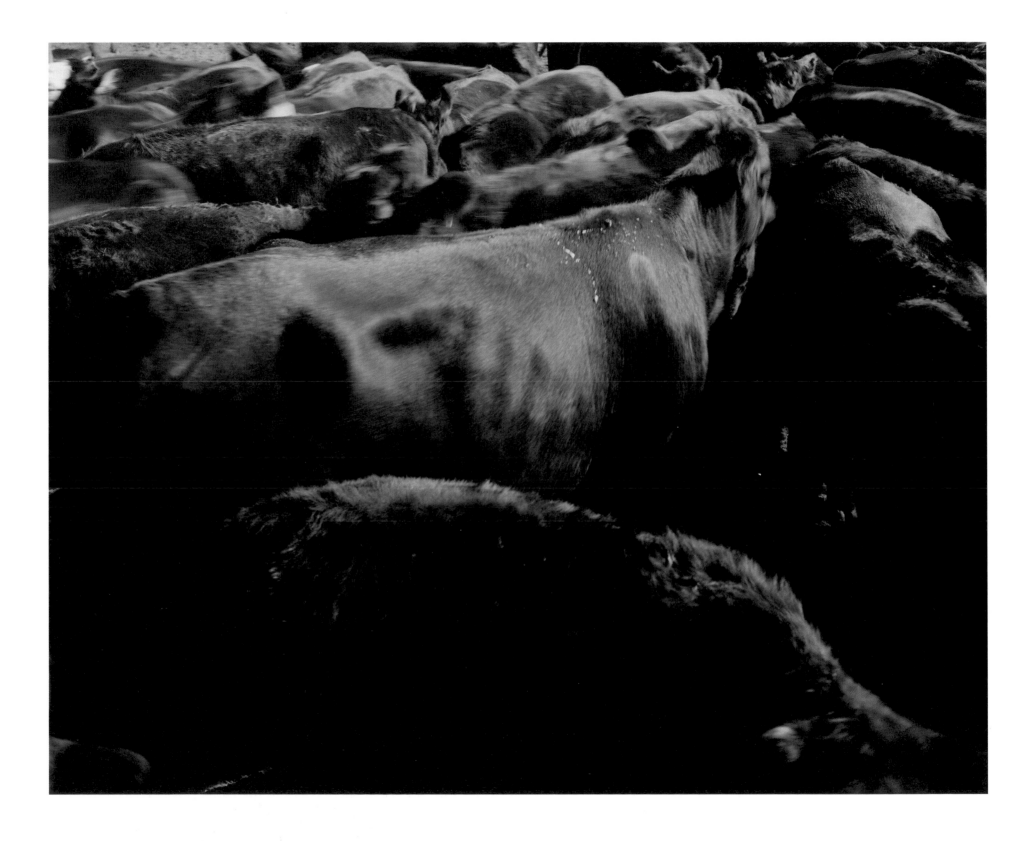

Sorting Black Angus Cow/Calf Pairs, Morgan Williams Ranch, Custer County, Idaho, 2003

Mattie with a Bourbon Red Turkey, Laverty Ranch, Custer County, Idaho, November, 2004

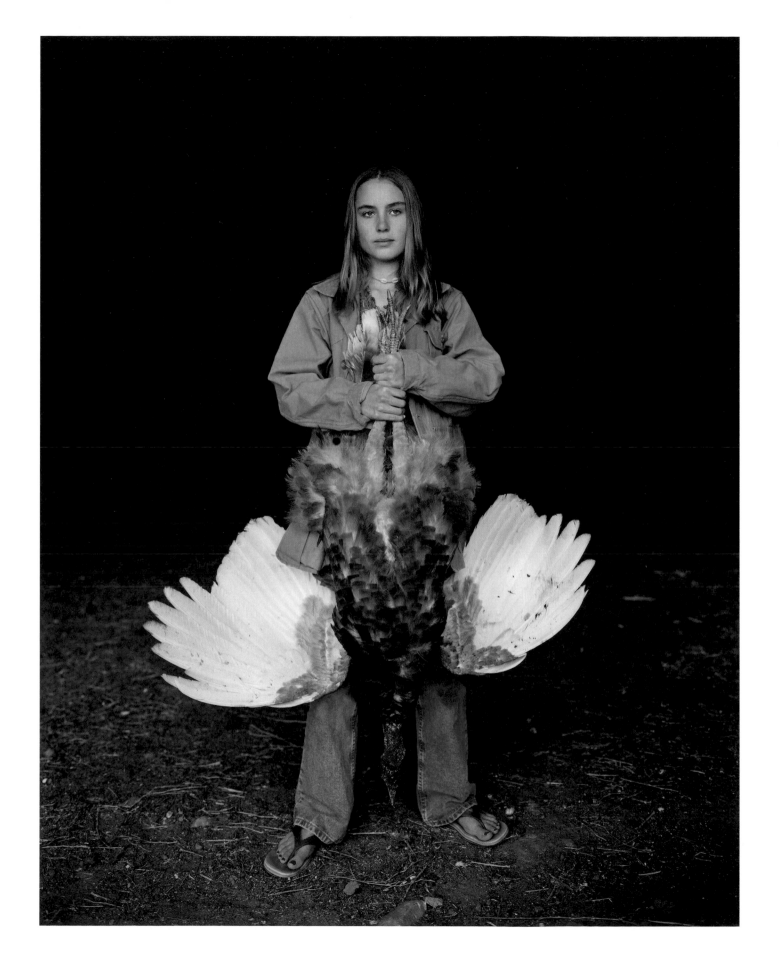
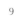

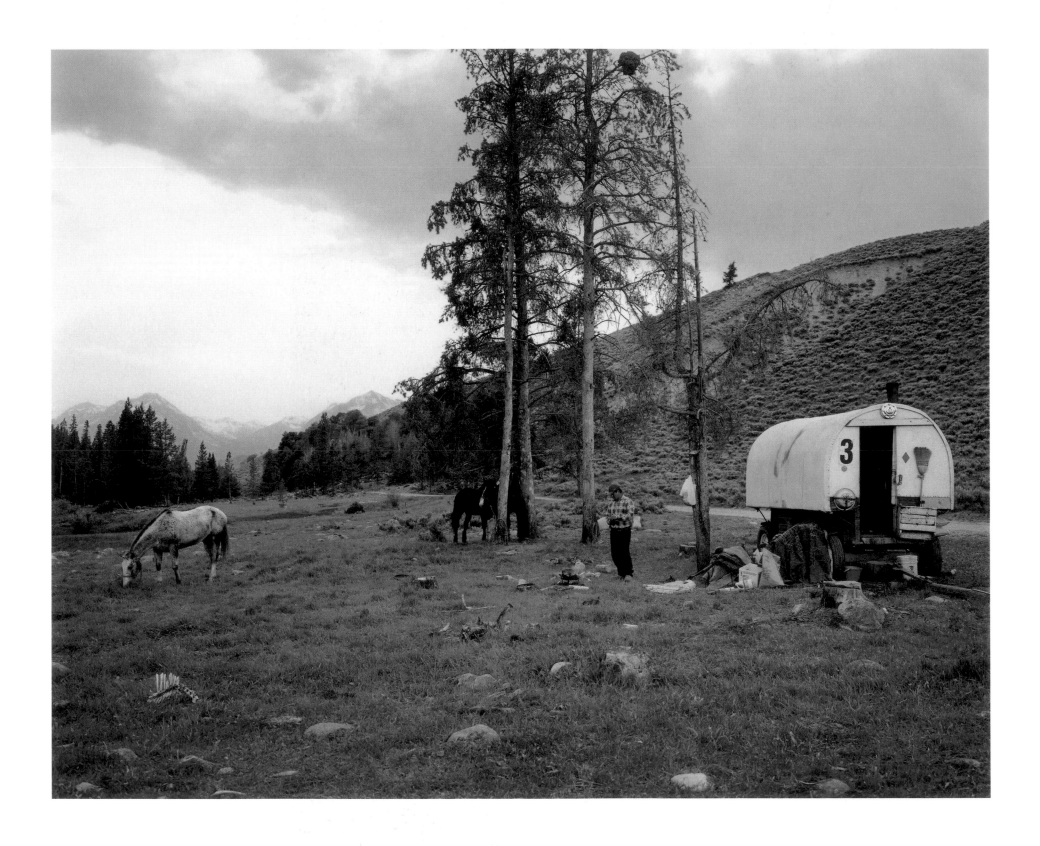

Gamaniel Tacza, Peruvian Shepherd, Fourth of July Creek, White Cloud Mountains, Idaho, 2003

Aspens Carved by Sheep Herders, Fisher Creek, White Cloud Mountains, Idaho, Summer Solstice, 2003

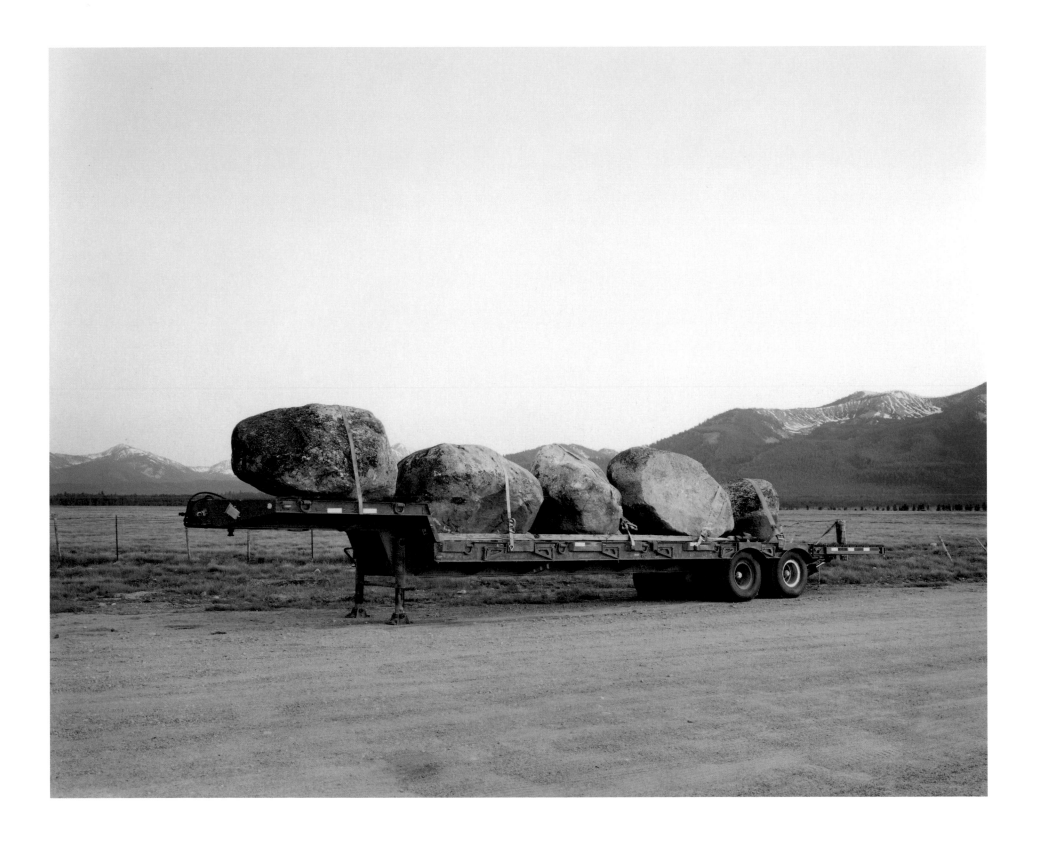

Rocks from Sawtooth National Forest for Landscaping in Sun Valley, Pettit Lake Road, Blaine County, Idaho, 2003

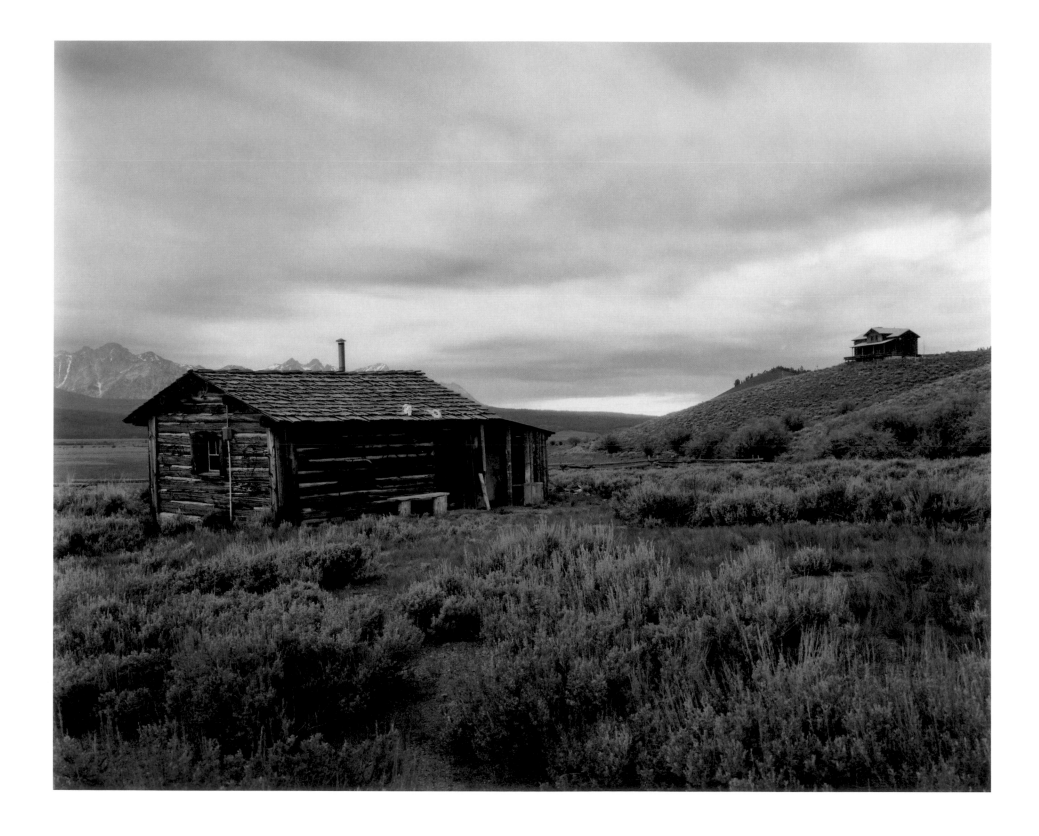

Nineteen-twenties Settlers' Cabin at the Edge of a Subdivision, Sawtooth Valley, Idaho, 2003

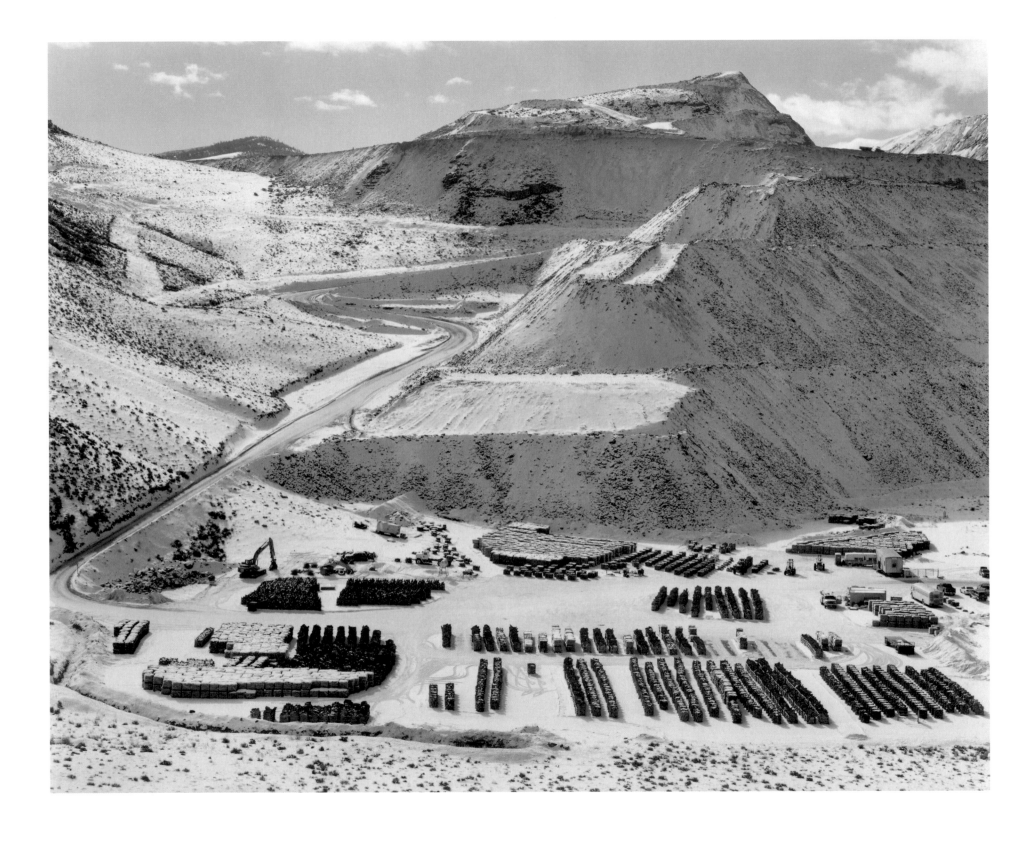

Three Rivers Stone Quarry, Clayton, Idaho, 2008

Little Redfish Lake Campground, Custer County, Idaho, 2003

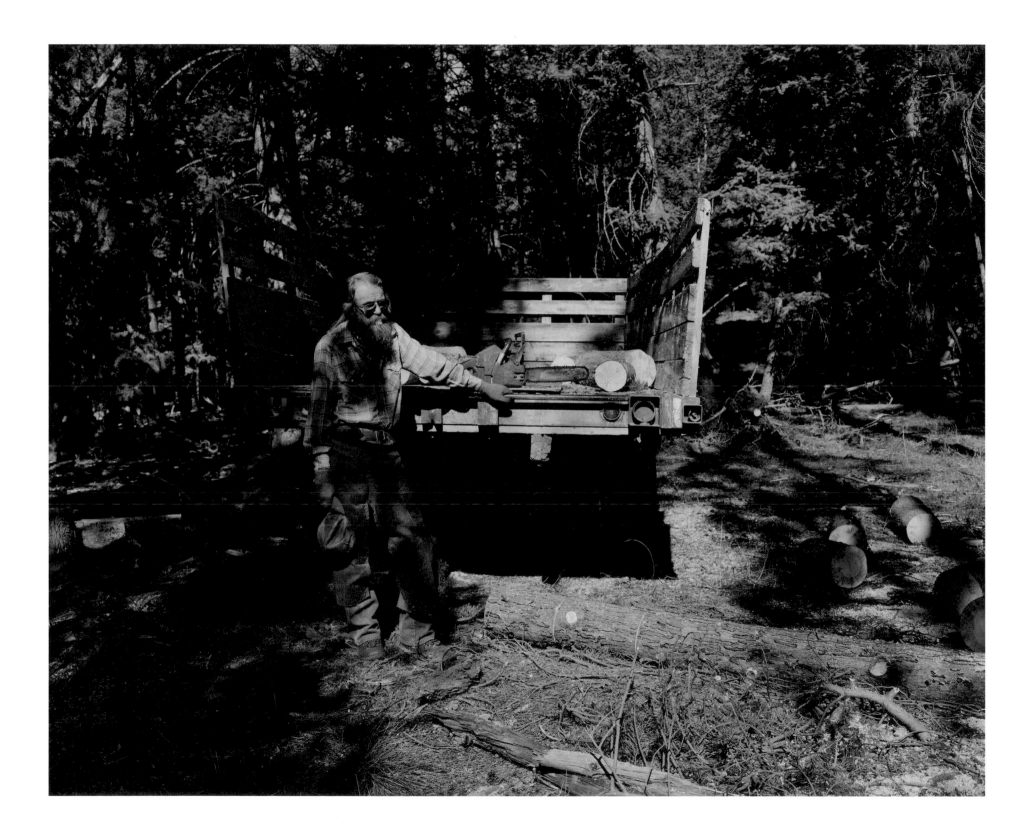

Tom Thurber Cutting Firewood, Lost Creek, Custer County, Idaho, 2003

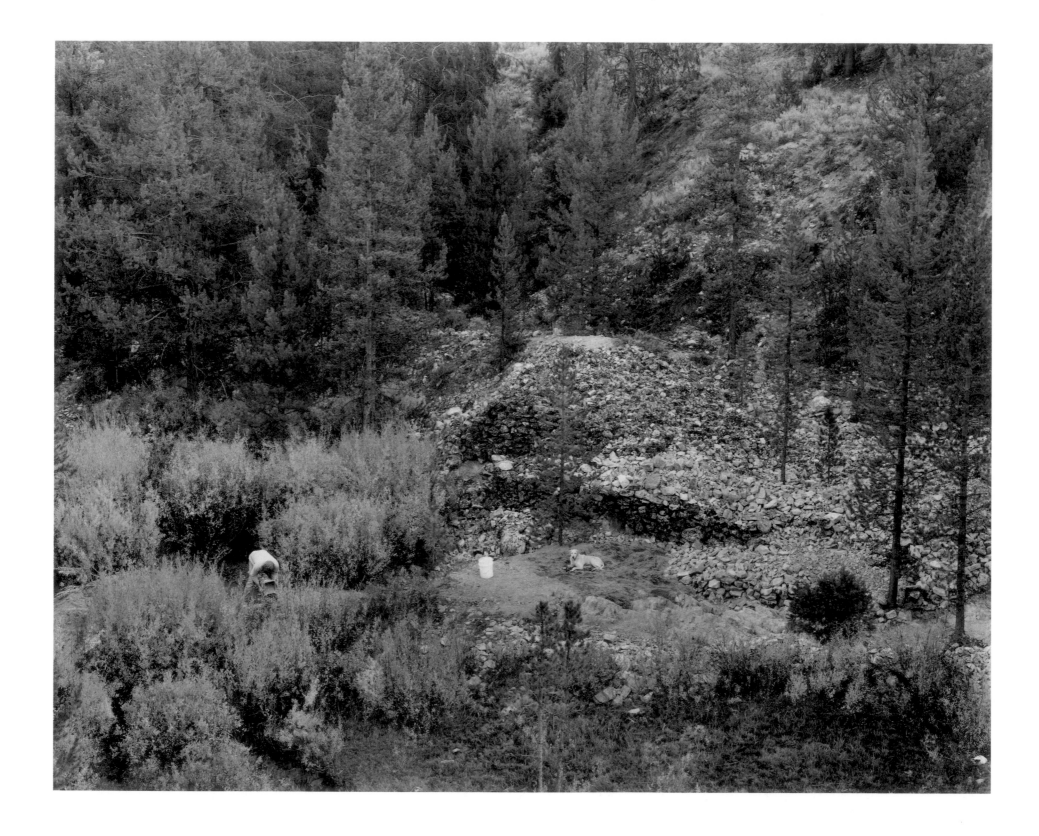

Mark Anderson Panning for Gold in 19th Century Tailings, Joe's Gulch, Lower Stanley, Idaho, 2003

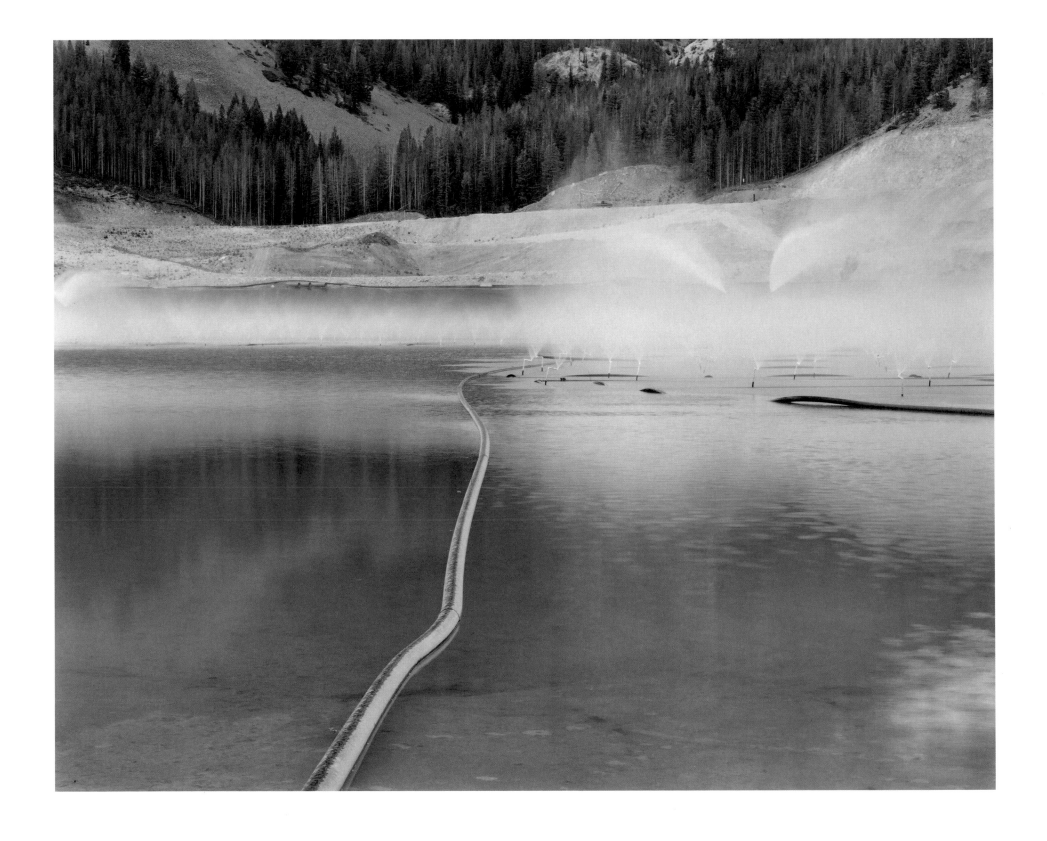

Cyanide Evaporation Pool by the River of No Return Wilderness, Grouse Creek Lead, Silver and Gold Mine, Yankee Fork, Idaho, 2005

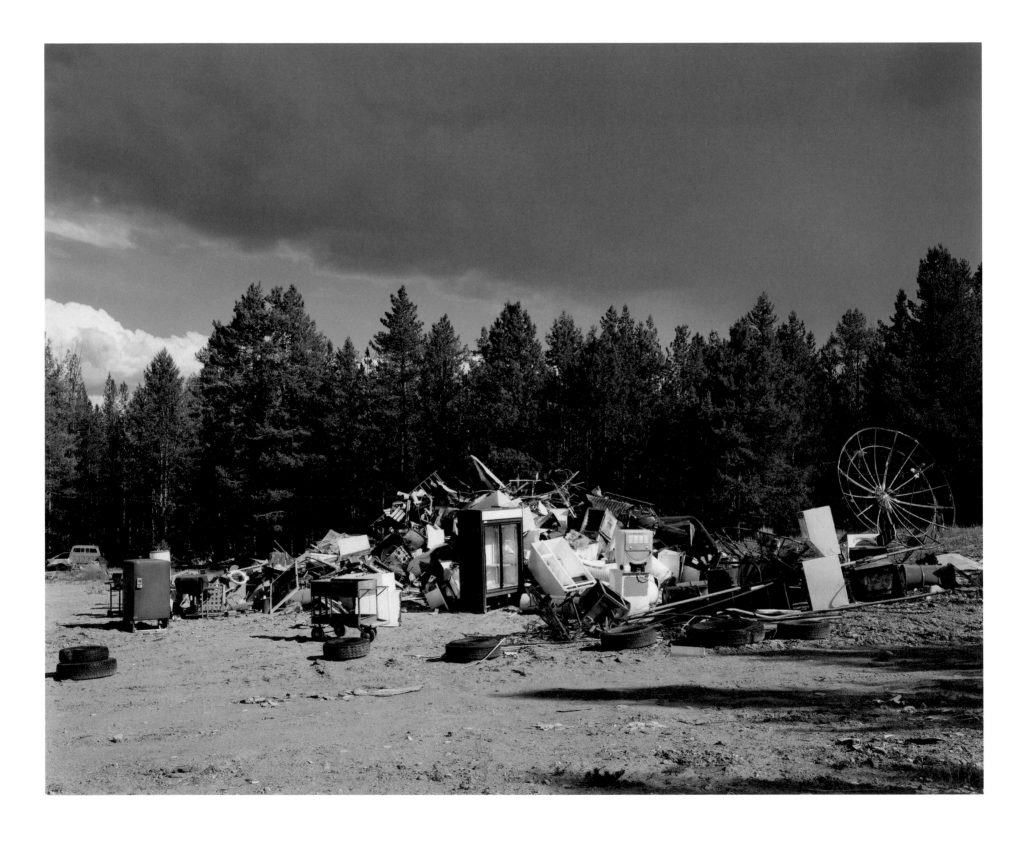

Salvage, Custer County Transfer Station, Stanley, Idaho, 2004

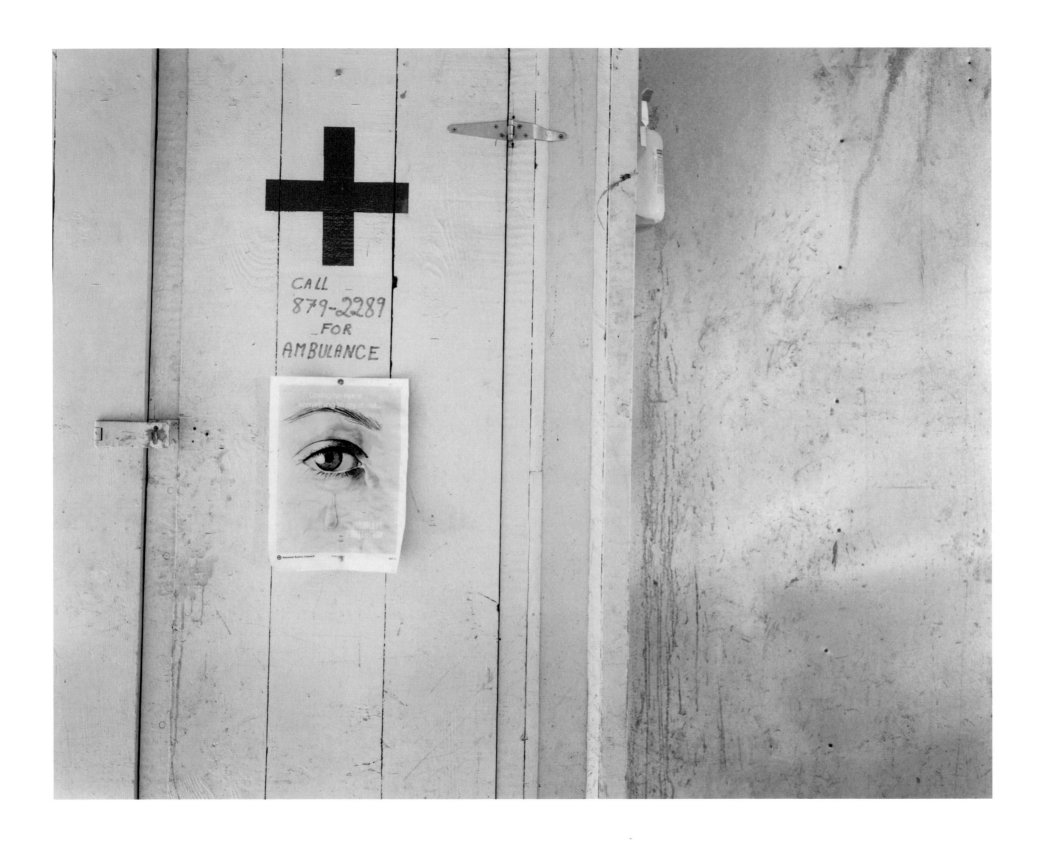

Men's Changing Room, Clayton Lead-Silver Mine, Kinnikinik Creek, Custer County, Idaho, 2004

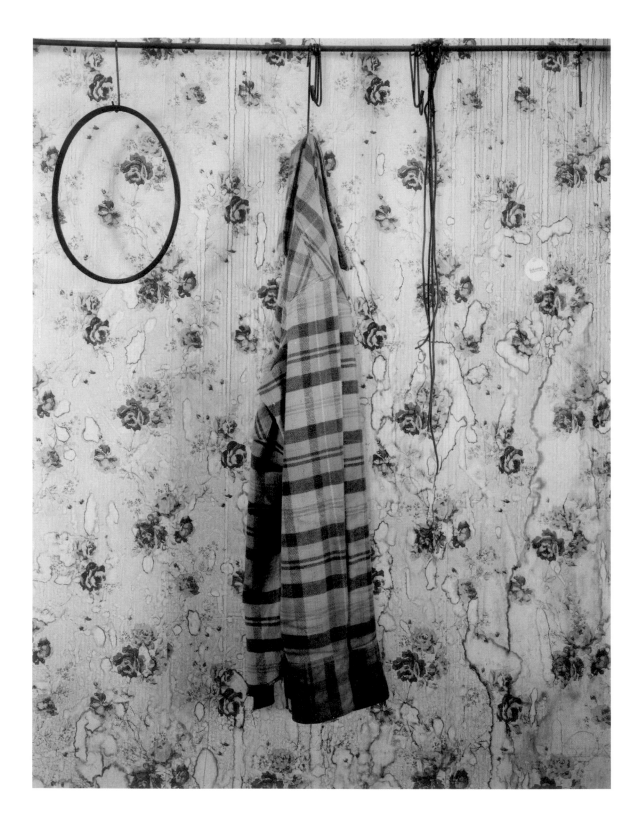

Ladies' Changing Room, Clayton Lead-Silver Mine, Kinnikinik Creek, Custer County, Idaho, 2004

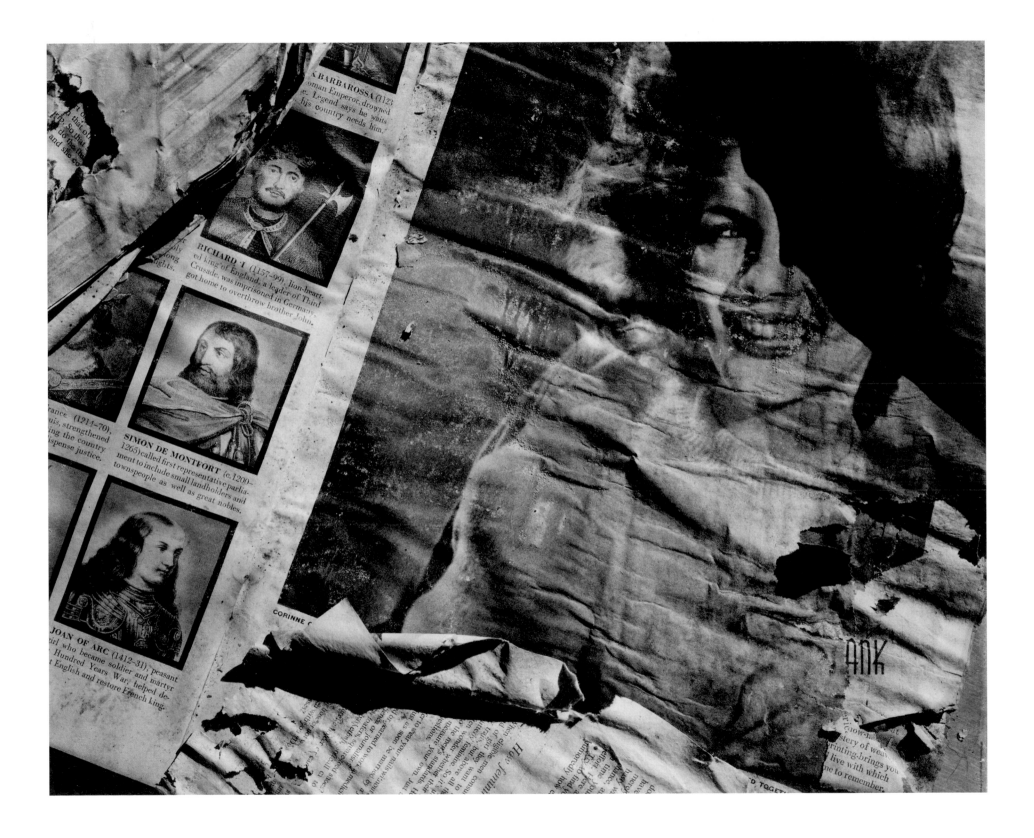

Nineteen-forties Women's Magazines at the Manager's House at Bayhorse Lead-Silver Mine, Custer County, Idaho, 2004

26

Nineteen-seventies Magazine, Old Obsidian, Idaho, 2004

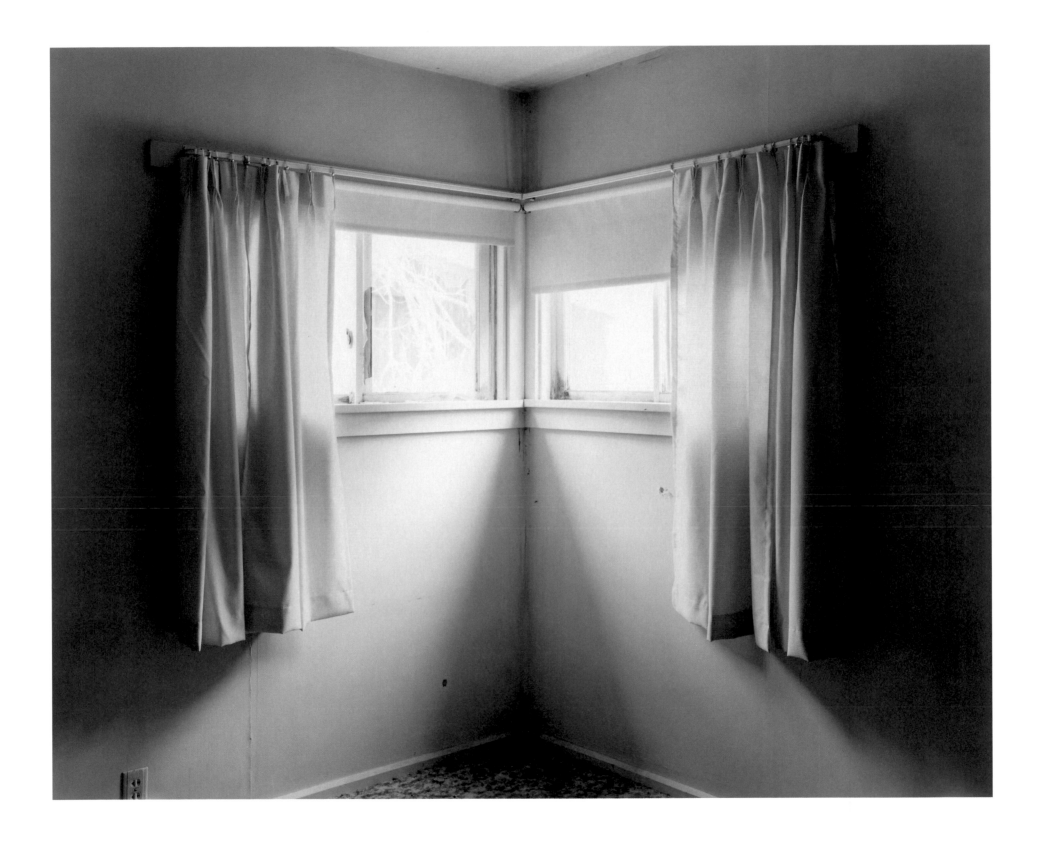

Master Bedroom, Manager's House, Clayton Lead-Silver Mine, Kinnikinik Creek, Custer County, Idaho, 2004

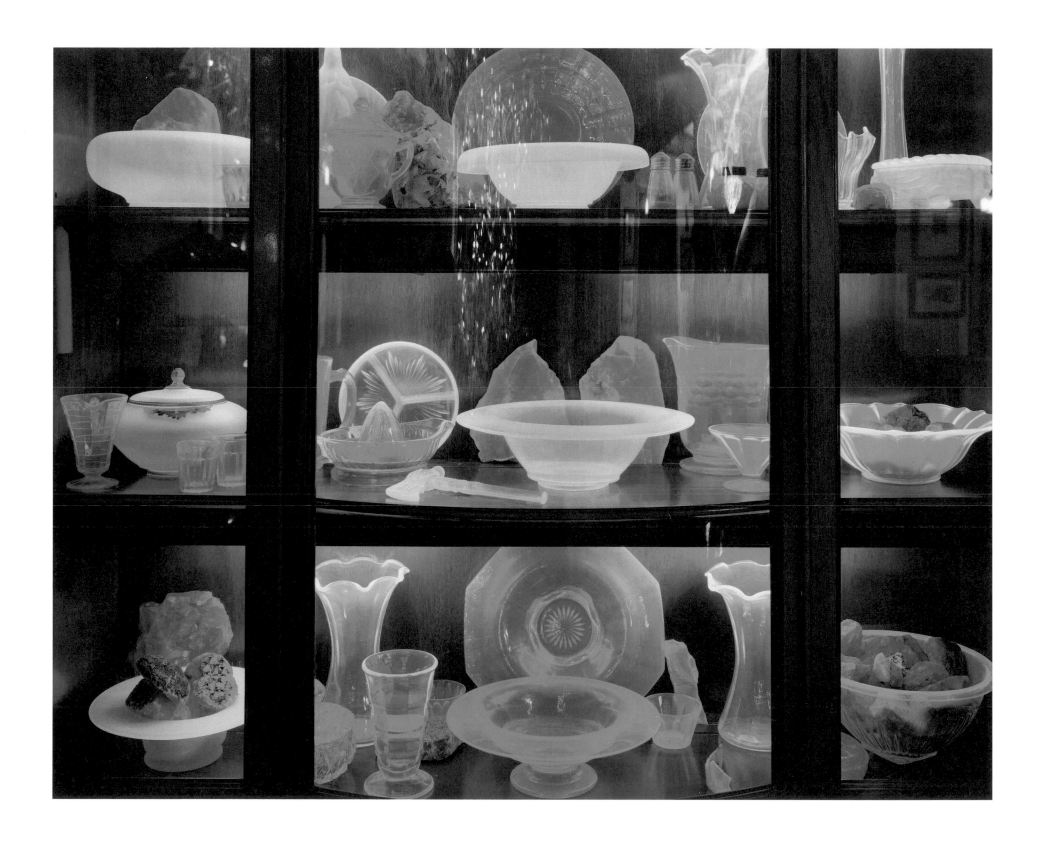

Depression Glass (Made with Uranium) and Fluorite Under a Black Light, Sawtooth City, Idaho, 2005

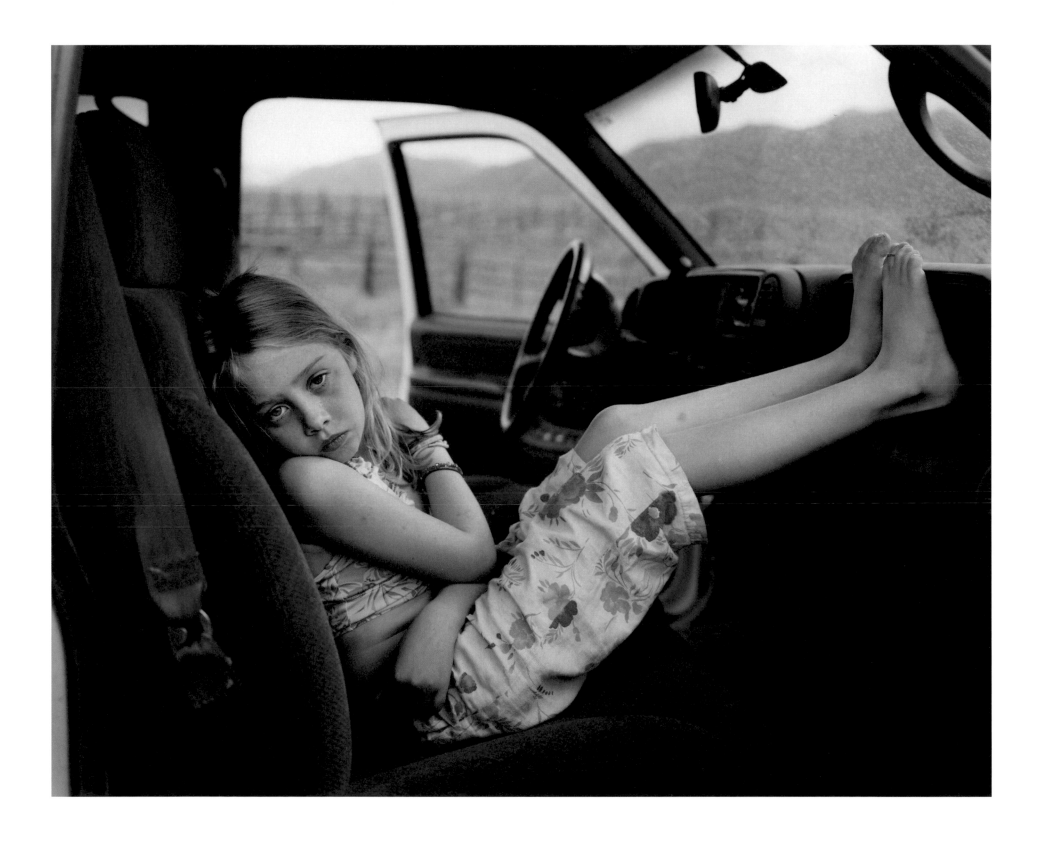

Isobel, Fourth of July Creek Ranch, Custer County, Idaho, 2004

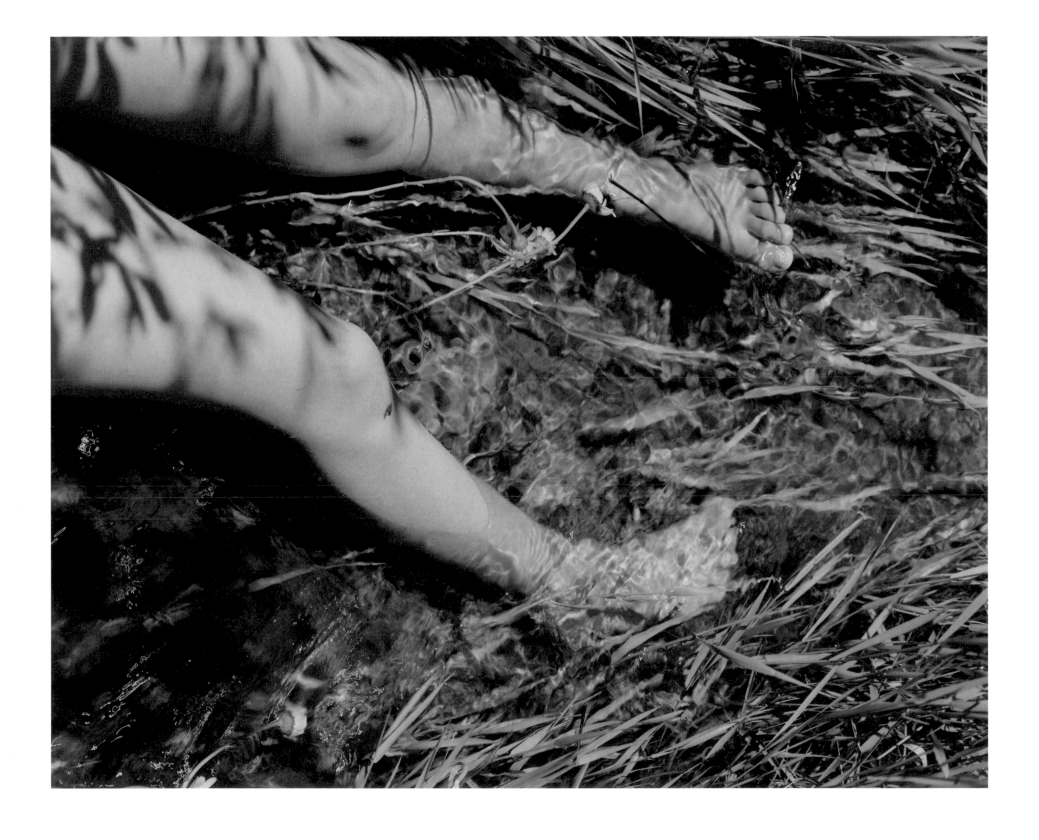

Irrigation Ditch, Fourth of July Creek Ranch, Custer County, Idaho, 2004

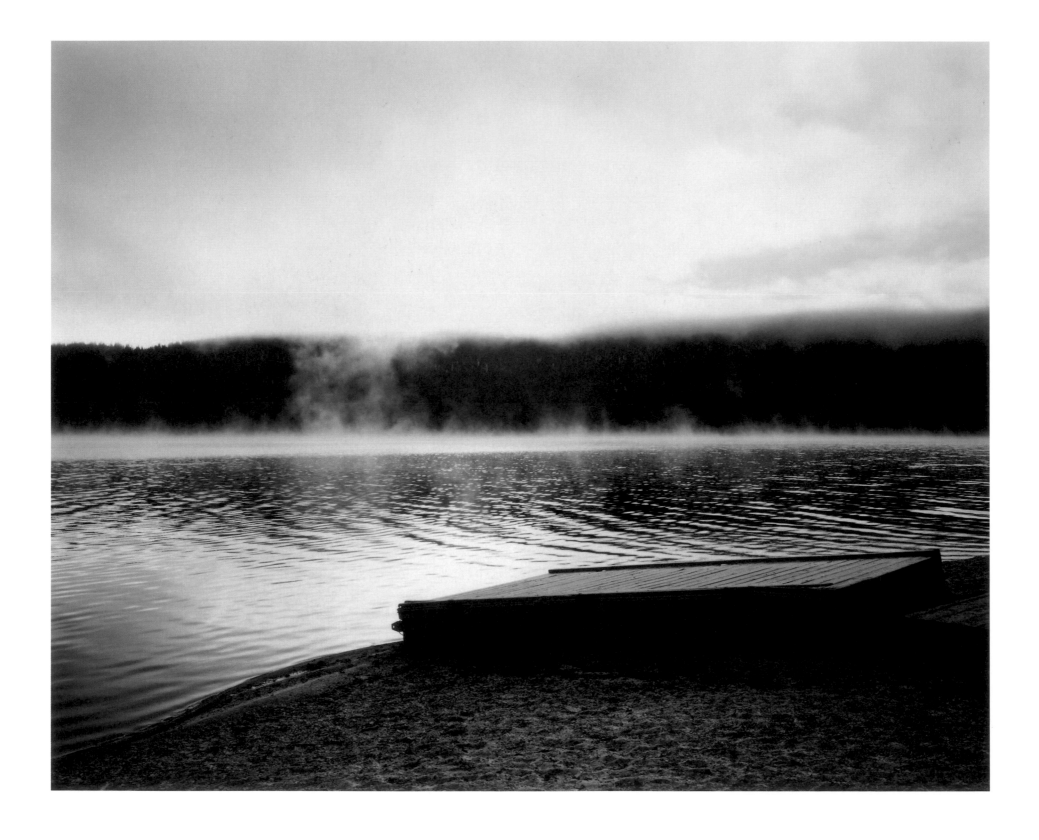

Floating Dock Beached for Winter, Alturas Lake, Blaine County, Idaho, 2004

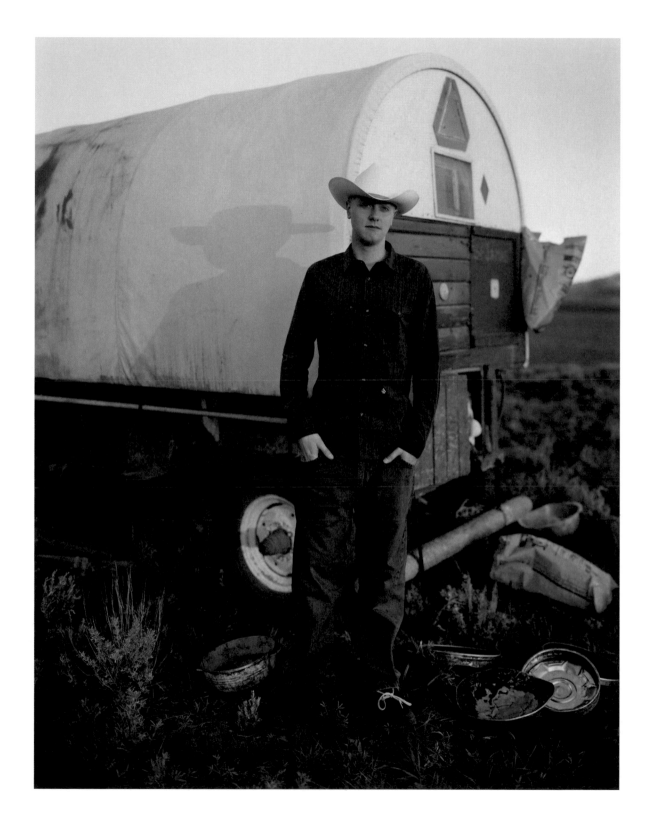

Matt Visiting Shepherd's Camp near Lost Creek, Custer County, Idaho, 2003

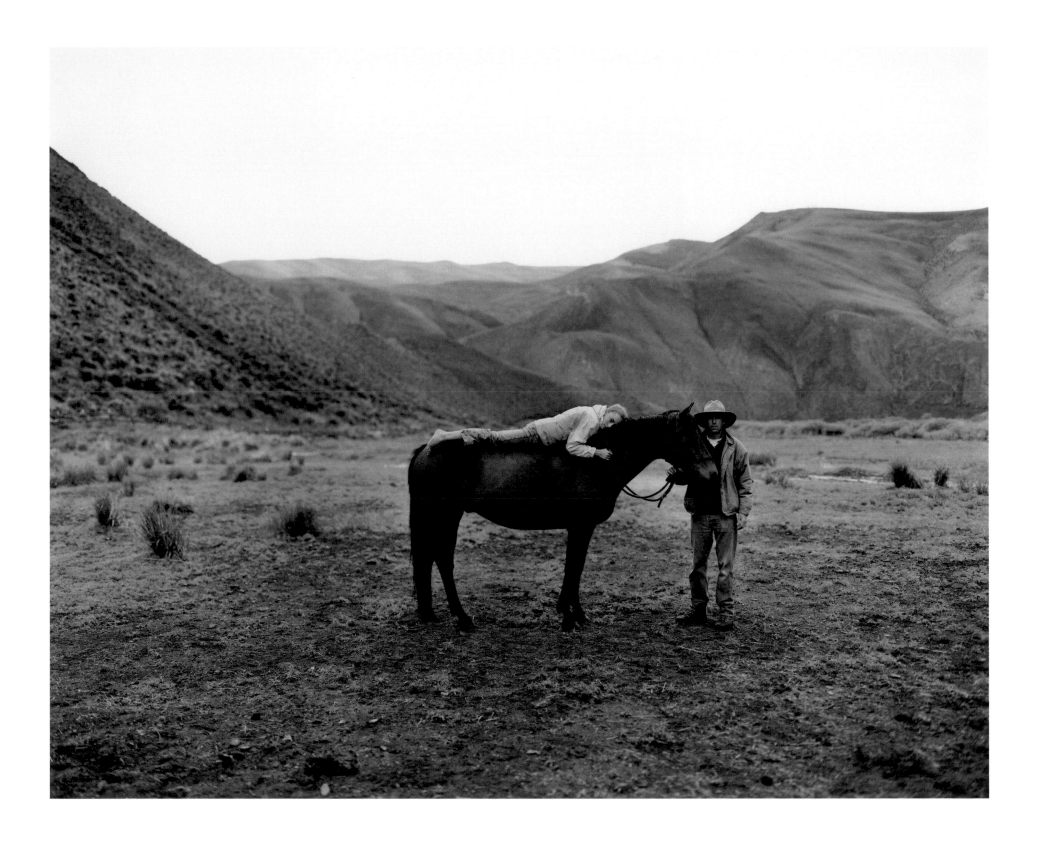

Mattie, Bob, and Bo, Road Creek, Custer County, Idaho, 2005

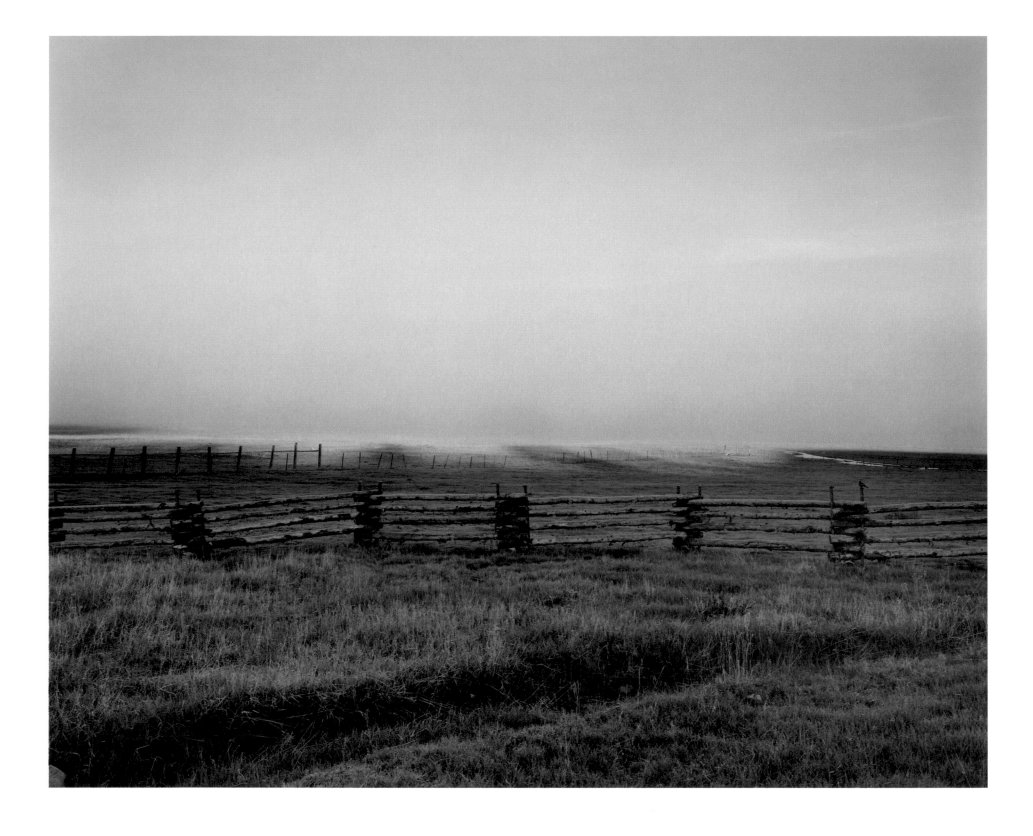

Fourth of July Creek Ranch, Custer County, Idaho, May 31, 2005

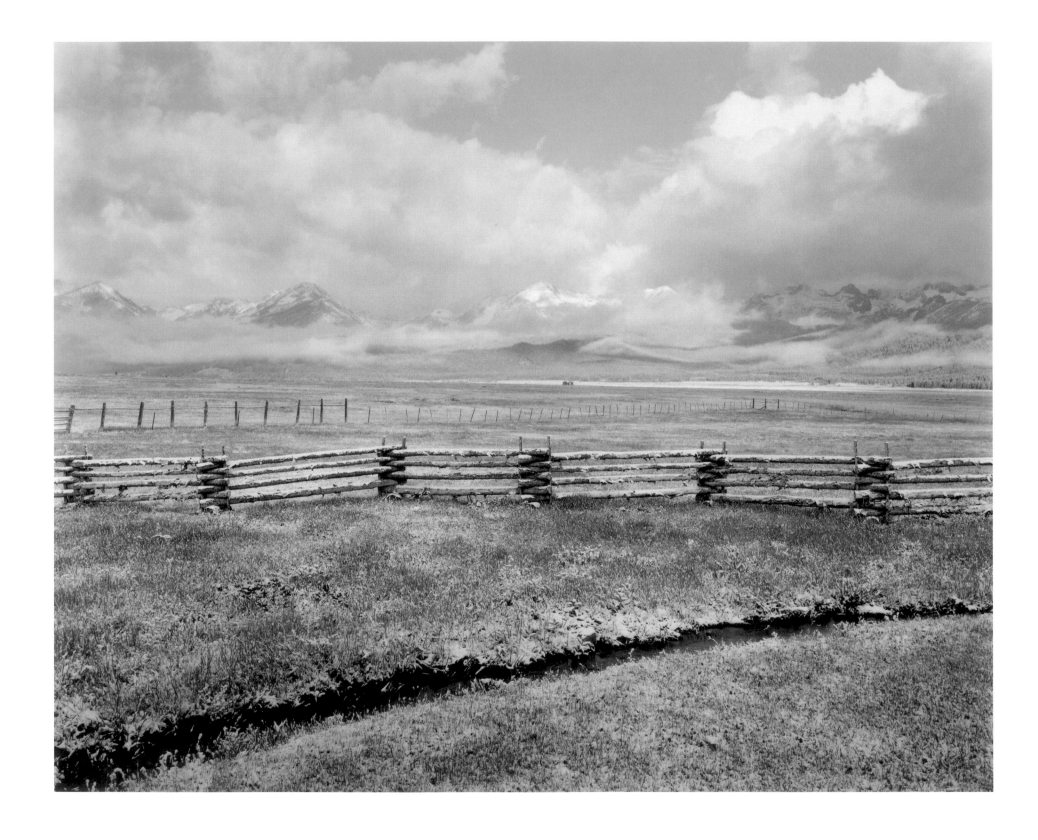

Fourth of July Creek Ranch, Custer County, Idaho, June 21, 2003

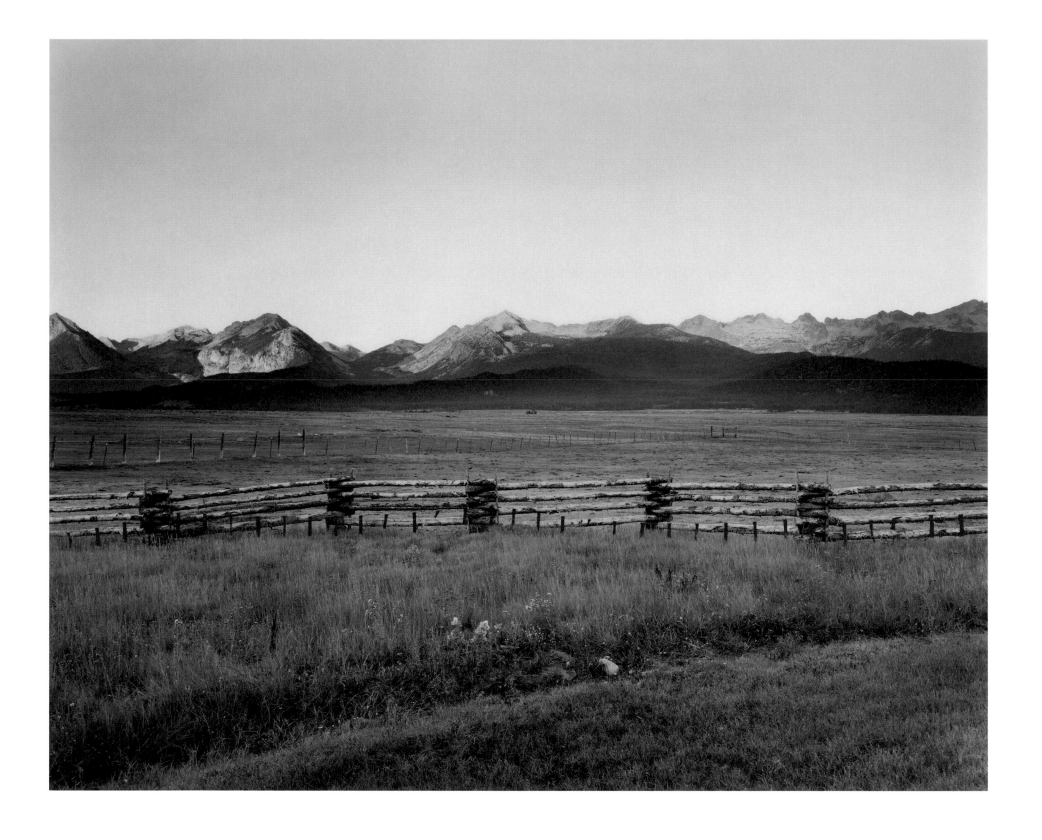

Red Fladry to Spook Wolves and Deter Them from Killing Calves, Fourth of July Creek Ranch, Custer County, Idaho, September 30, 2003

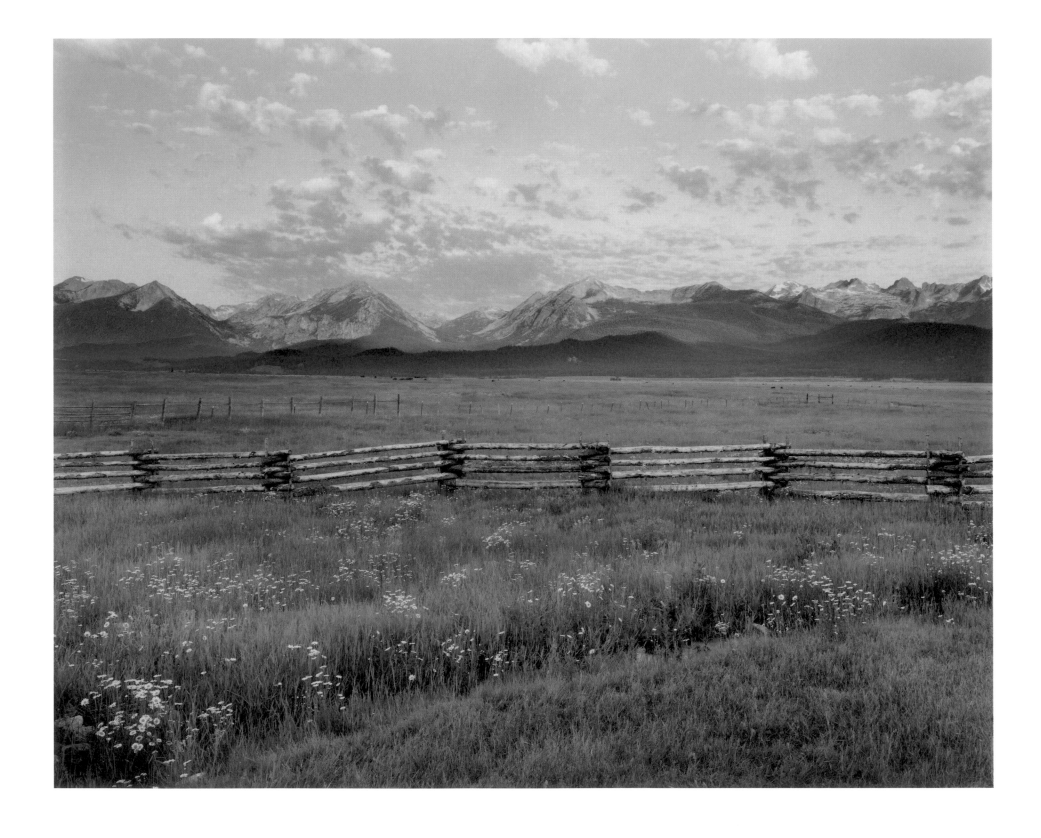

Fourth of July Creek Ranch, Custer County, Idaho, July 8, 2004

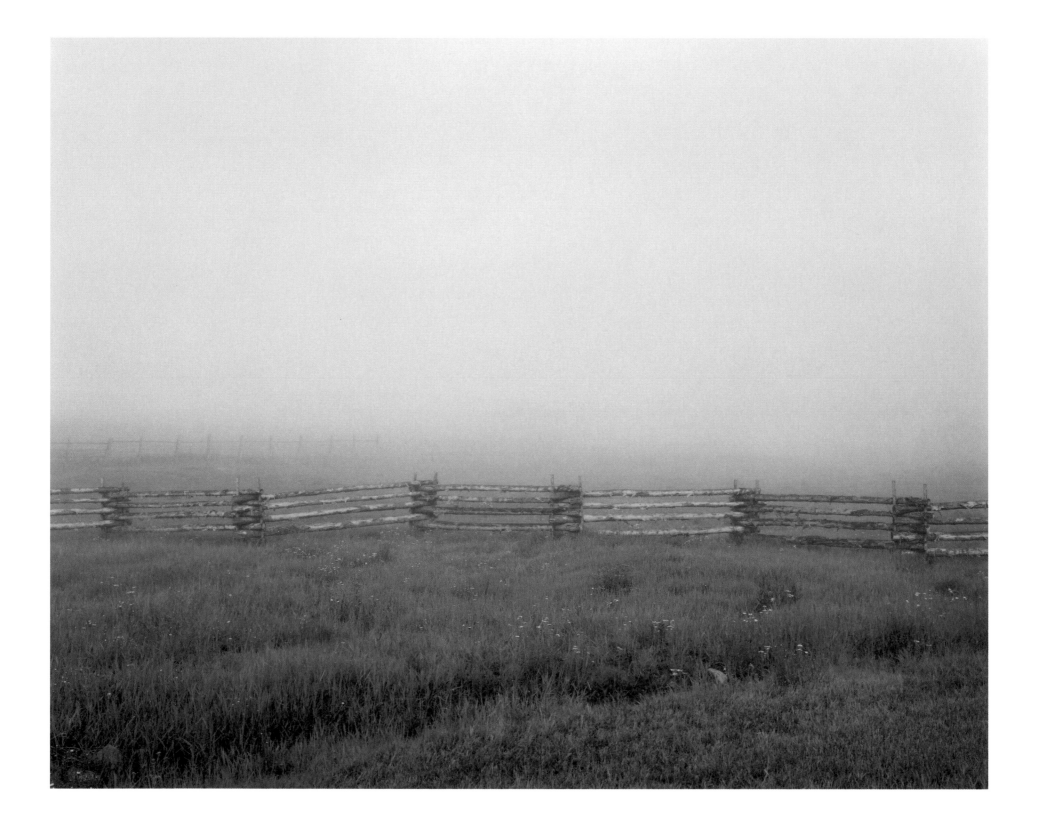

Fourth of July Creek Ranch, Custer County, Idaho, July 15, 2004

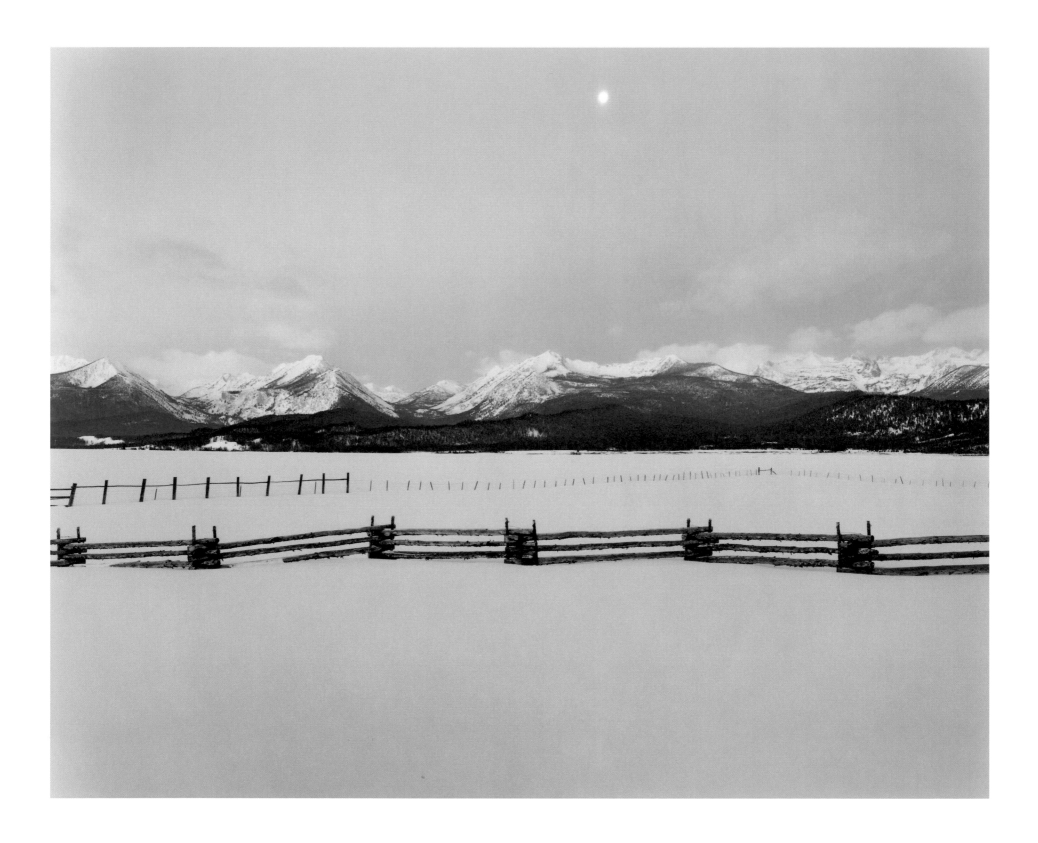

Moon Setting, Fourth of July Creek Ranch, Custer County, Idaho, January 27, 2008

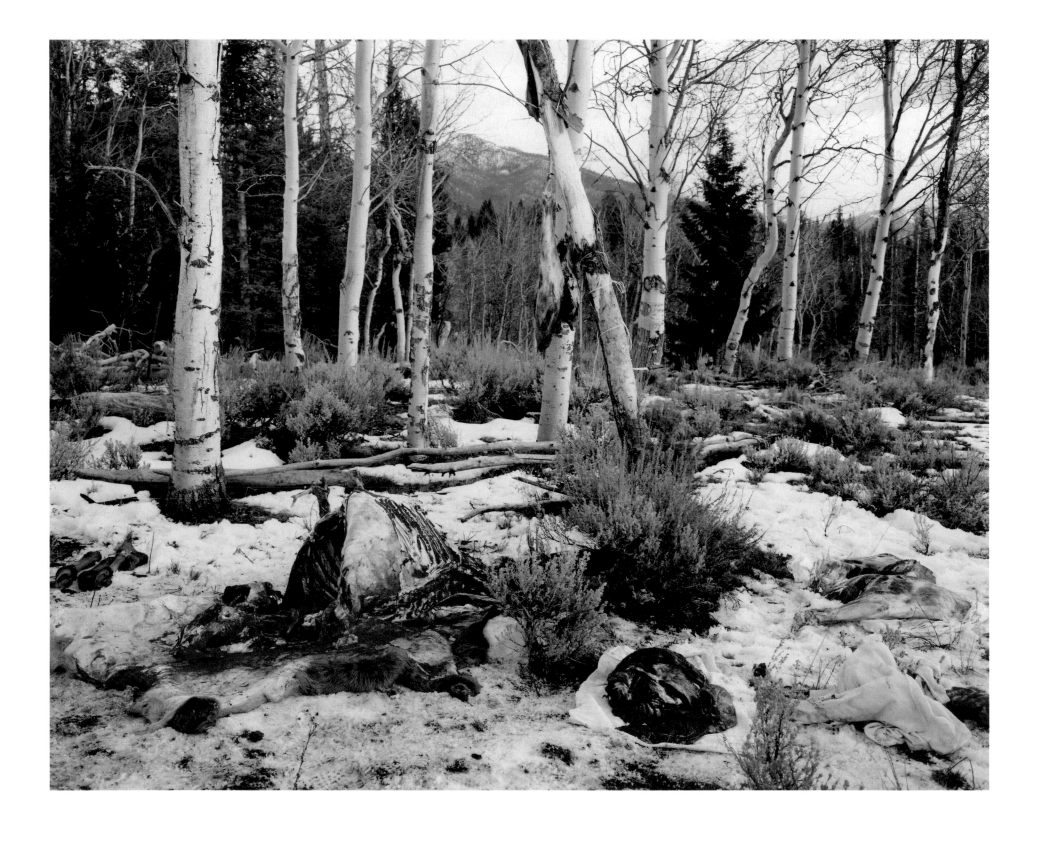

Quartered Rocky Mountain Elk, Milky Creek, White Cloud Mountains, Idaho, 2004

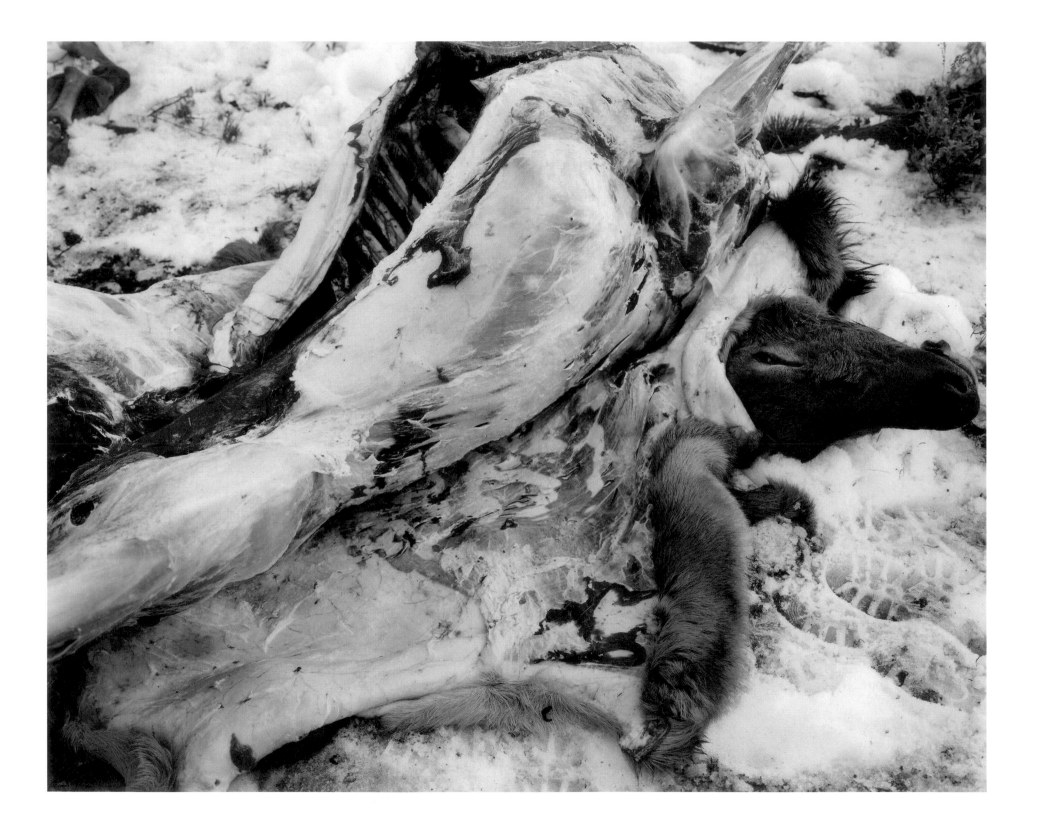

Skinned Elk, White Cloud Mountains, Idaho, 2004

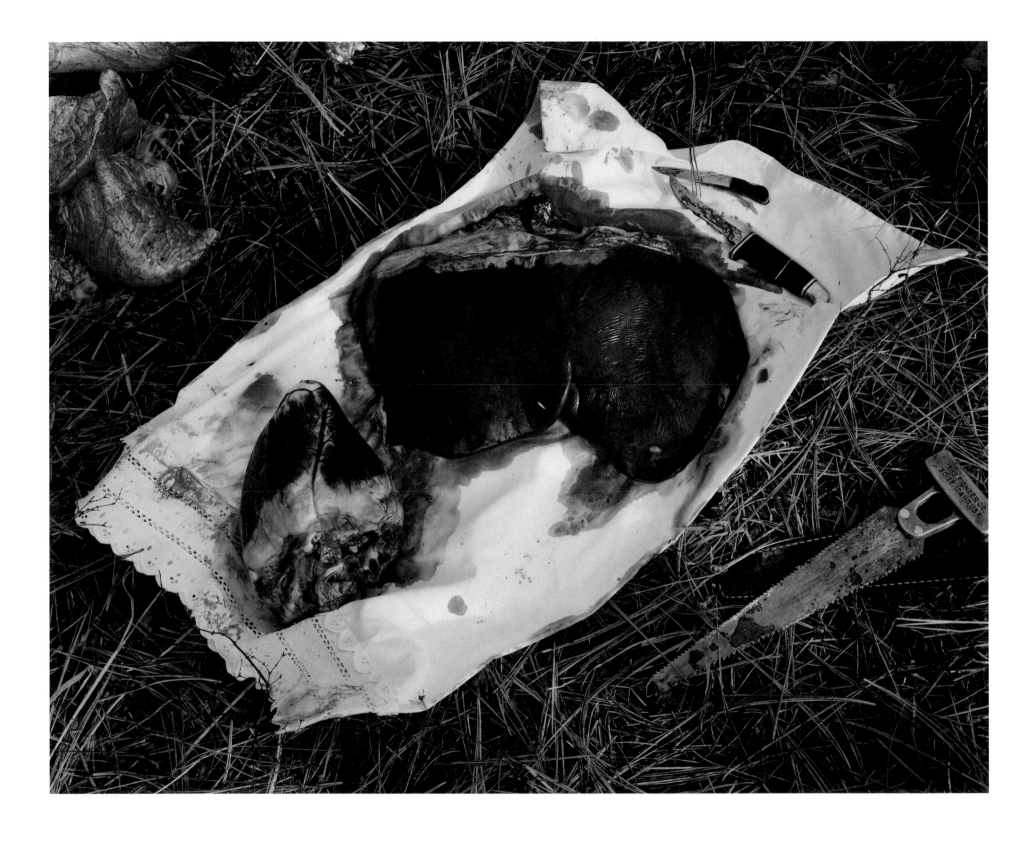

Elk Heart and Liver, Custer County, Idaho, 2004

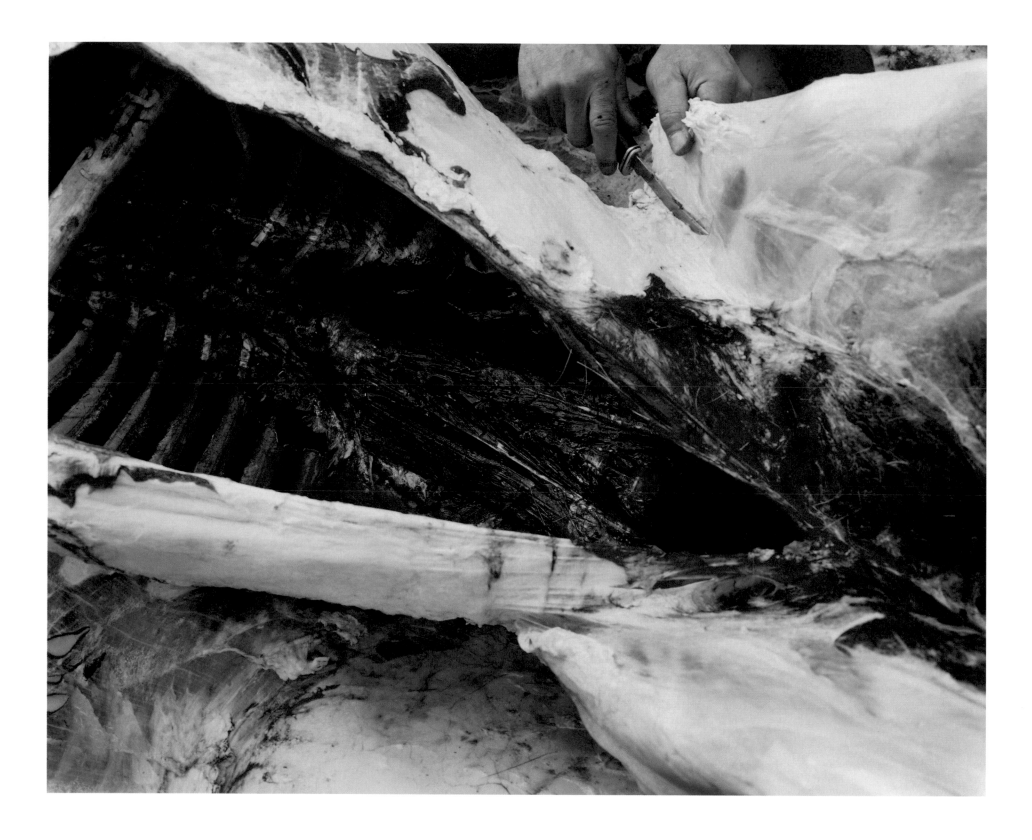

Chest Cavity, Rocky Mountain Cow Elk, Custer County, Idaho, 2004

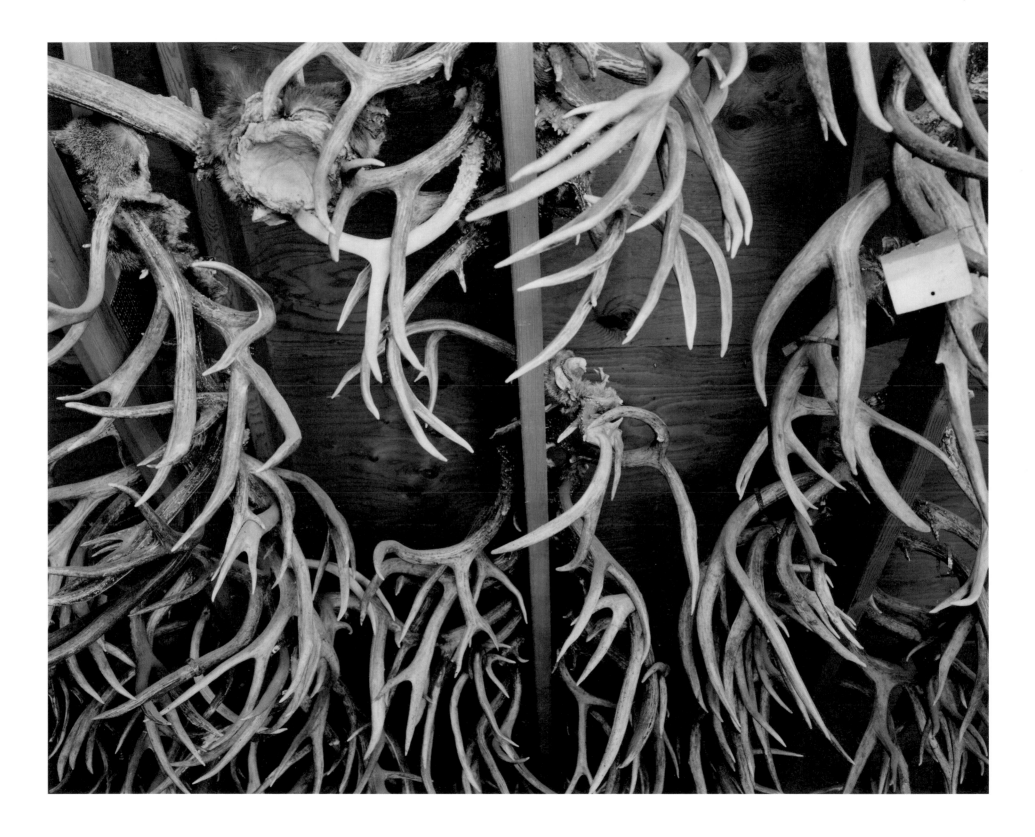

Antlers in the Rafters of a Barn, Highway 75 near Gold Creek, Custer County, Idaho, 2004

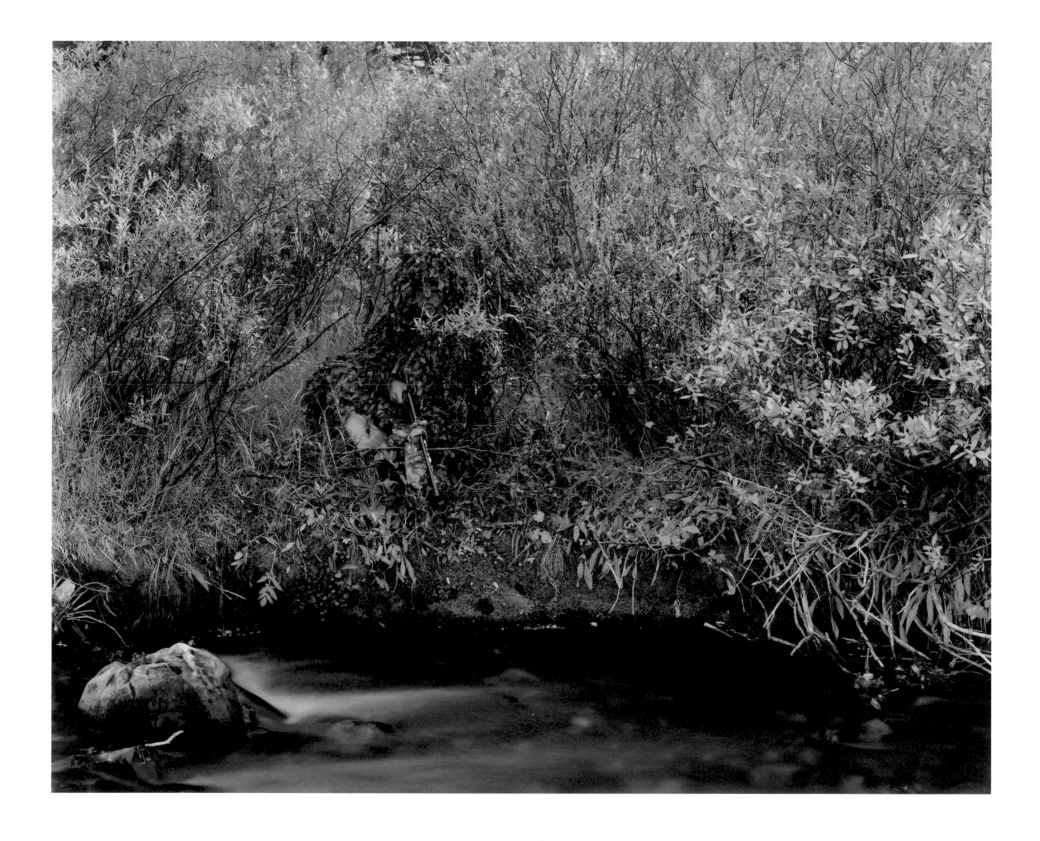

Isaac Babcock, Biologist for the Nez Perce Tribe, Dressed for Tranquilizing and Radio-Collaring Wolves, Fourth of July Creek, Custer County, Idaho, 2003

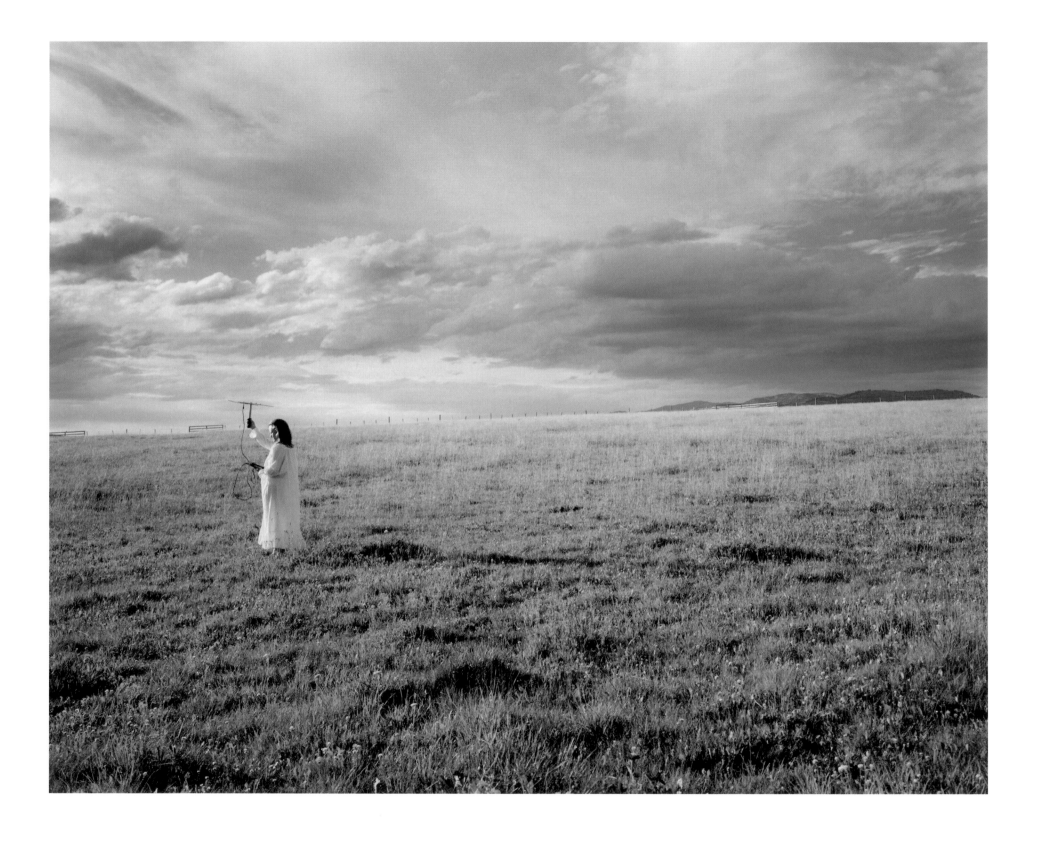

Judy Tracking Radio-Collared Wolves from Her Yard, Summer Range, H-Hook Ranch, Custer County, Idaho, 2004

Mattie in Her Eighth Grade Graduation Dress Holding a Robin's Nest, Laverty Ranch, Custer County, Idaho, May, 2005

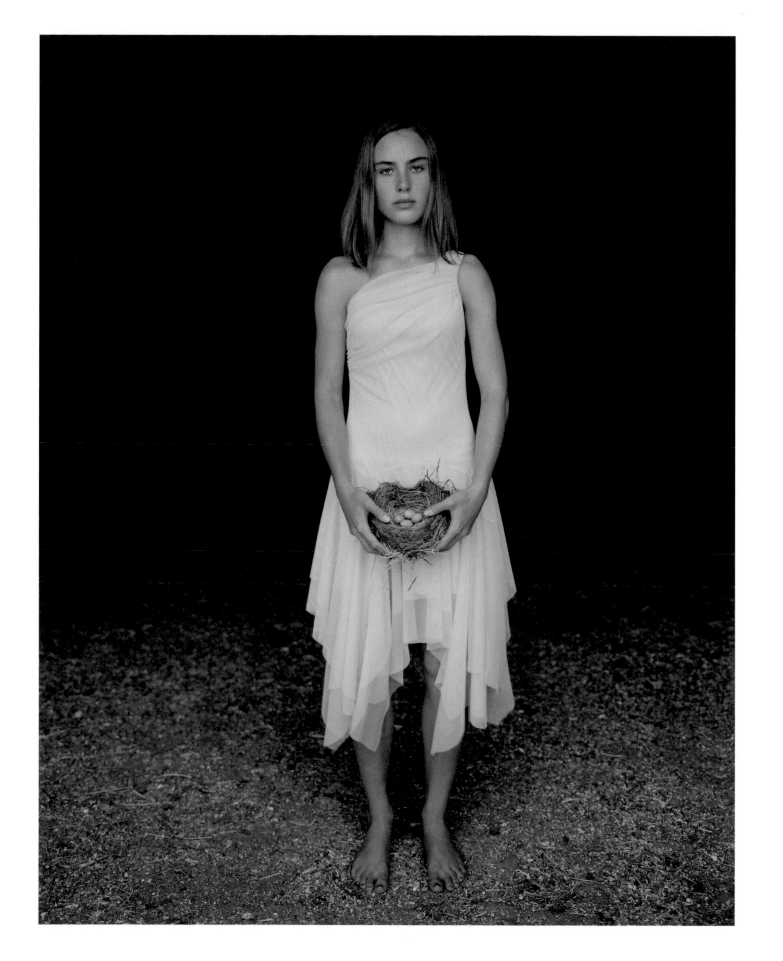

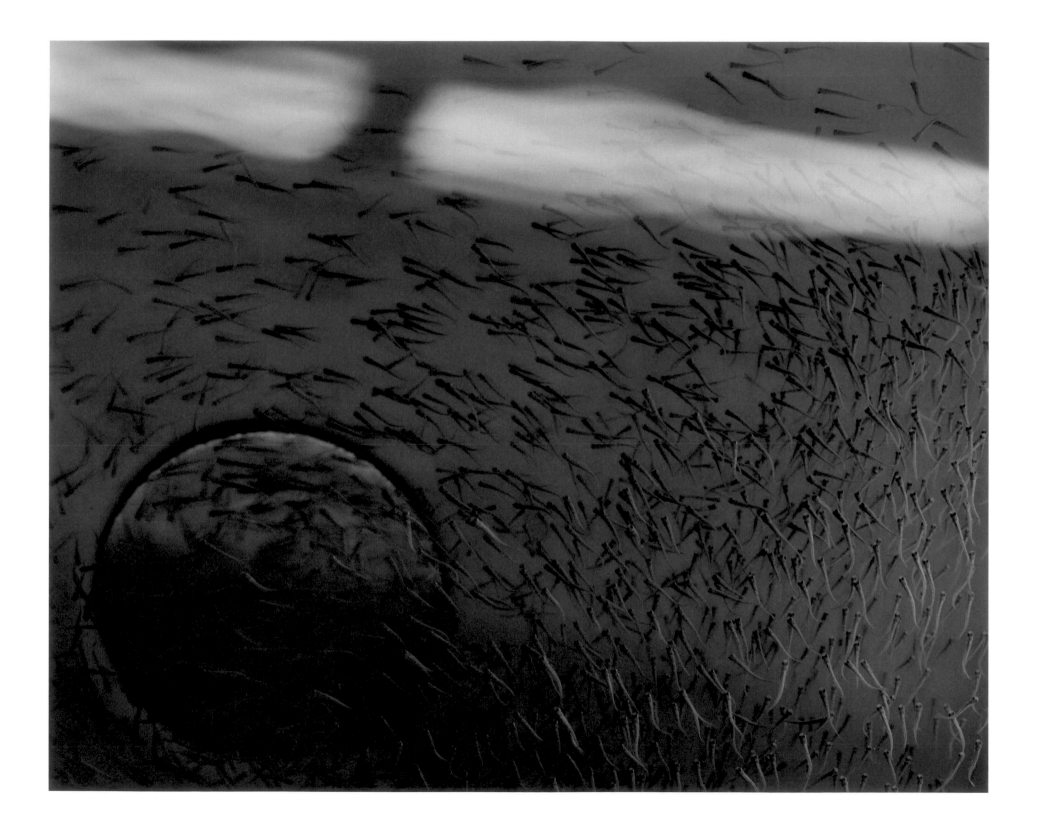

Endangered Sockeye Salmon Fry, Main Vat Room, Sawtooth Fish Hatchery, Custer County, Idaho, 2004

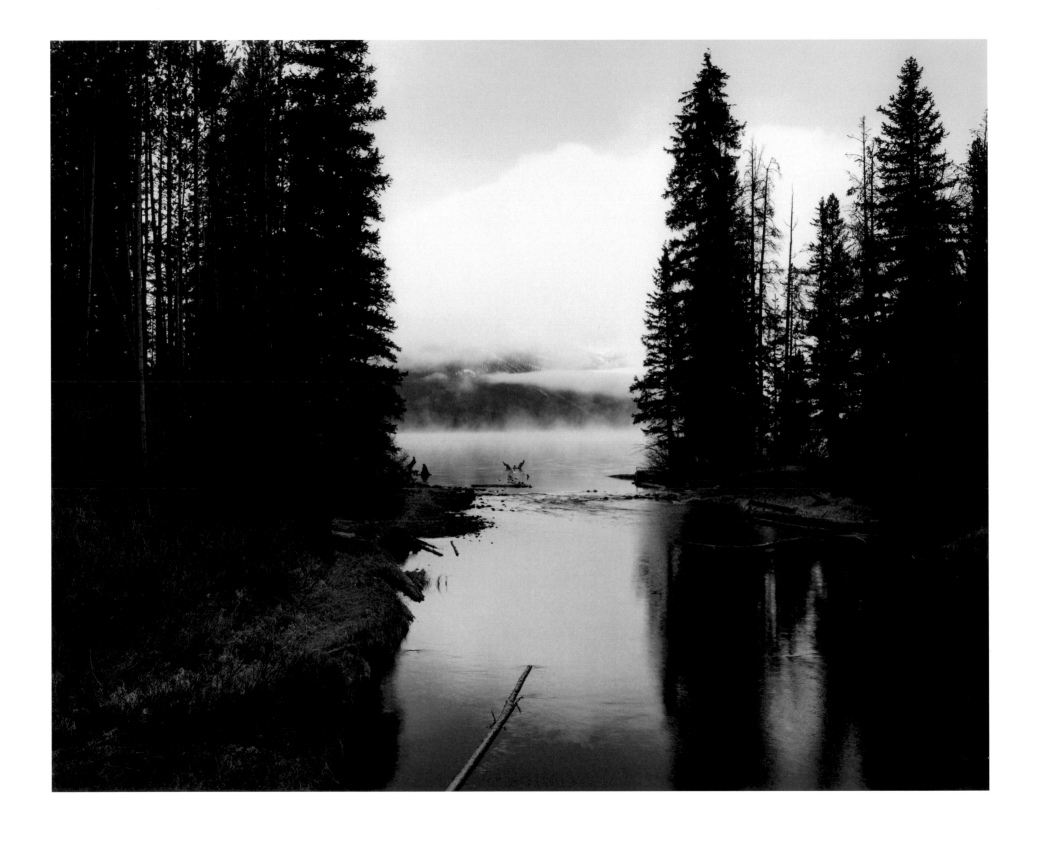

Alturas Lake Outlet, Blaine County, Idaho, 2004

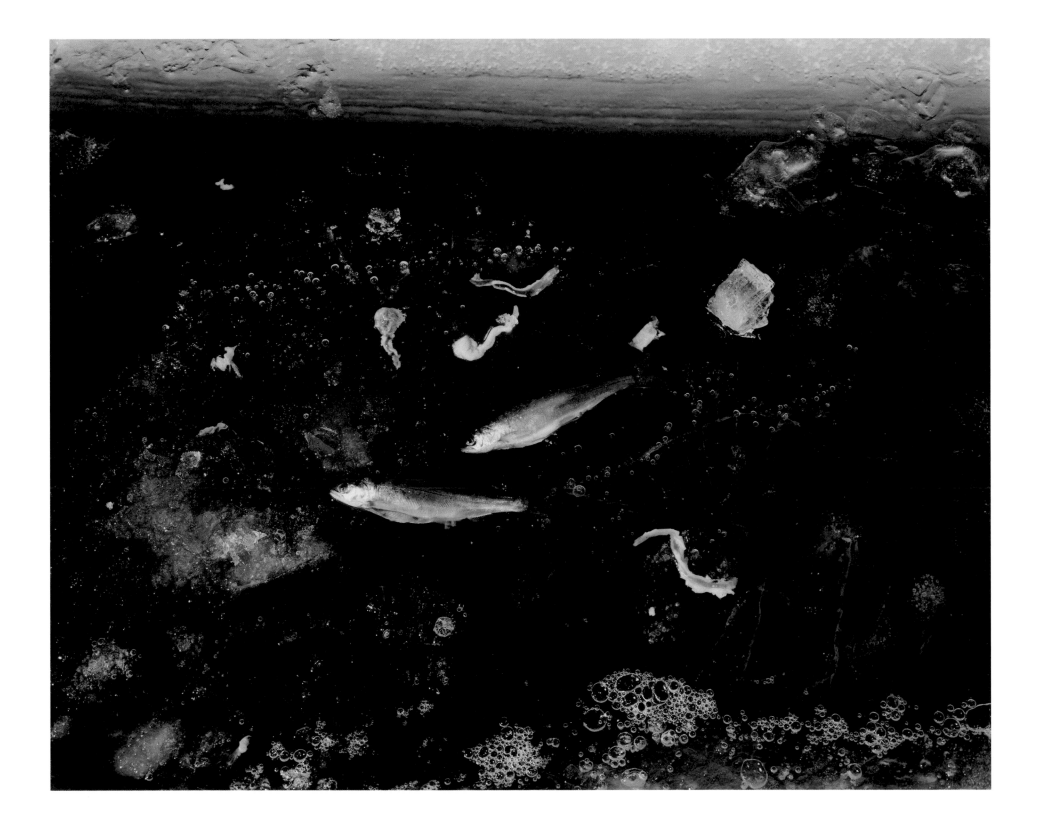

Winter Sampling to Study Growth and Diet of Endangered Snake River Sockeye Salmon, Pettit Lake, Blaine County, Idaho, 2004

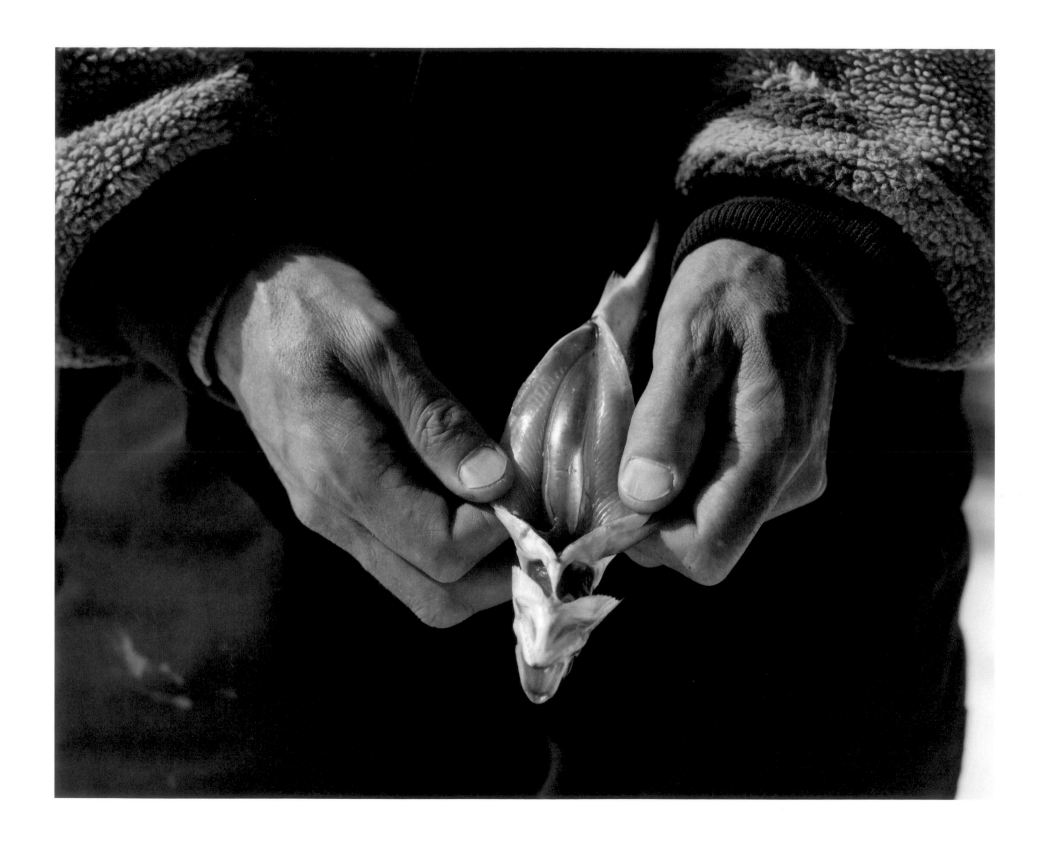

Air Bladder of an Endangered Sockeye Salmon, Pettit Lake, Blaine County, Idaho, 2005

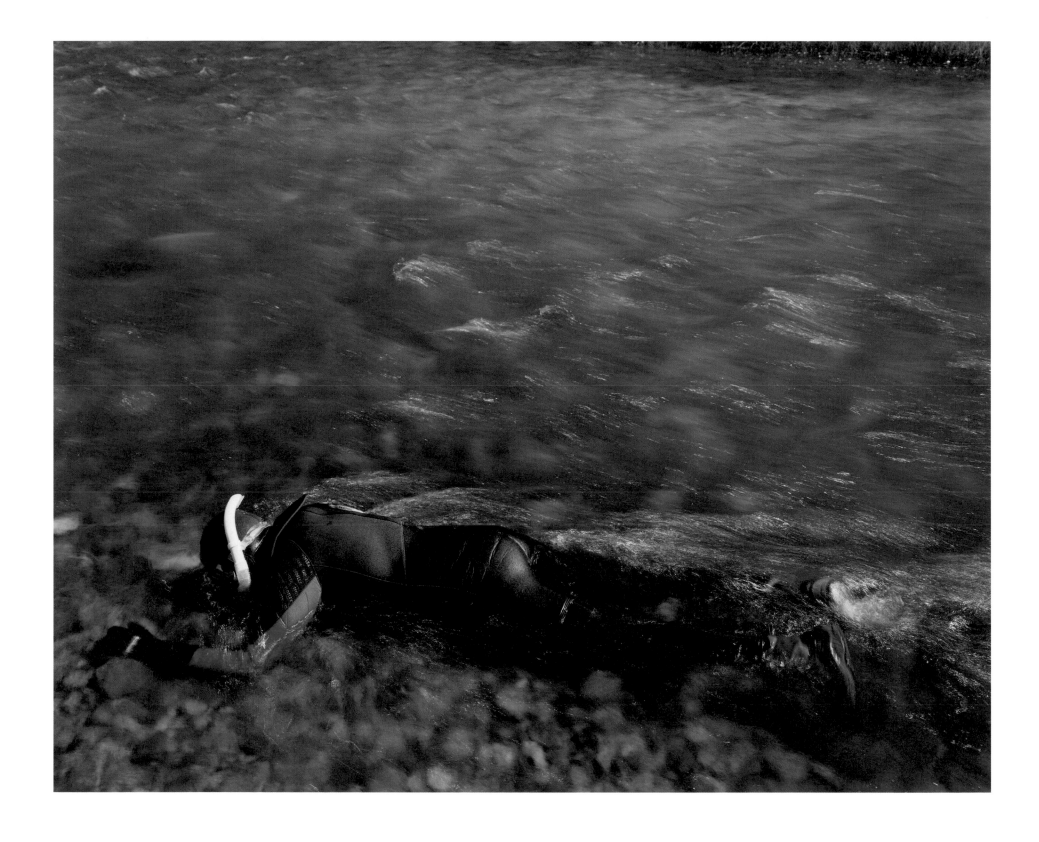

Rob Trahant, Shoshone-Bannock Tribal Member, Counting Fish for Juvenile Chinook Salmon Survey, Valley Creek, Custer County, Idaho, 2004

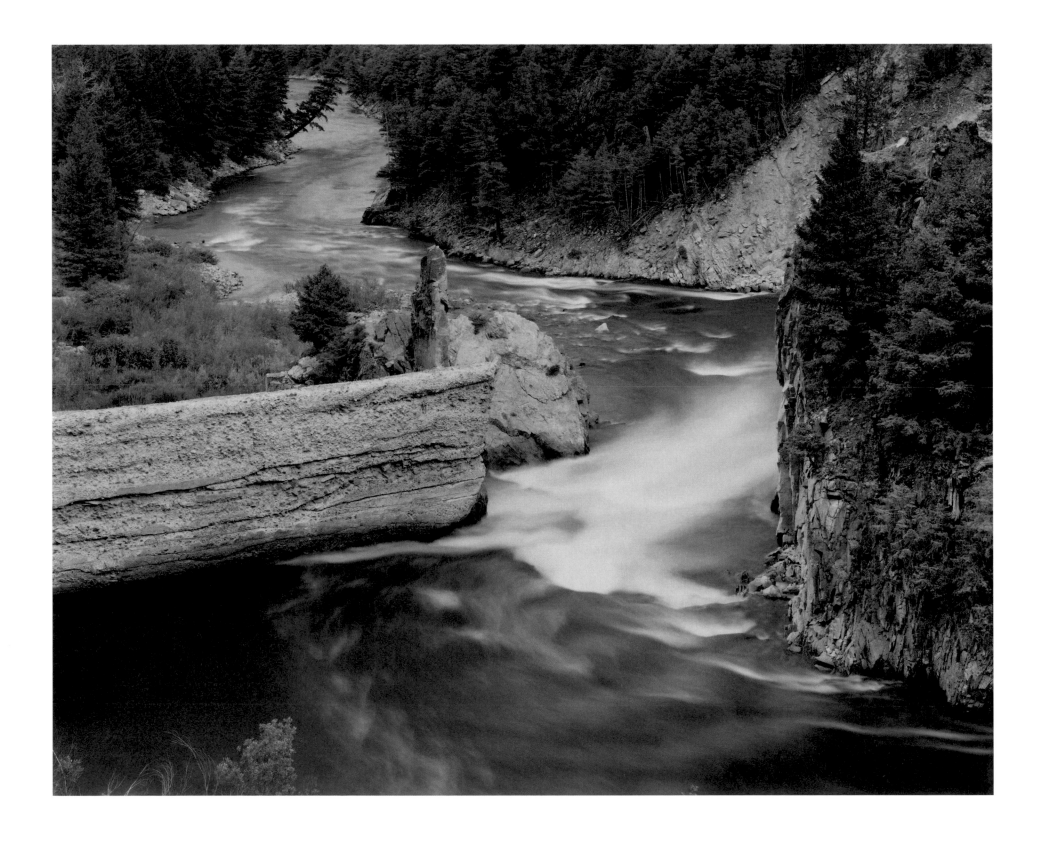

Breached Dam at Sunbeam on the Salmon River, Custer County, Idaho, 2003

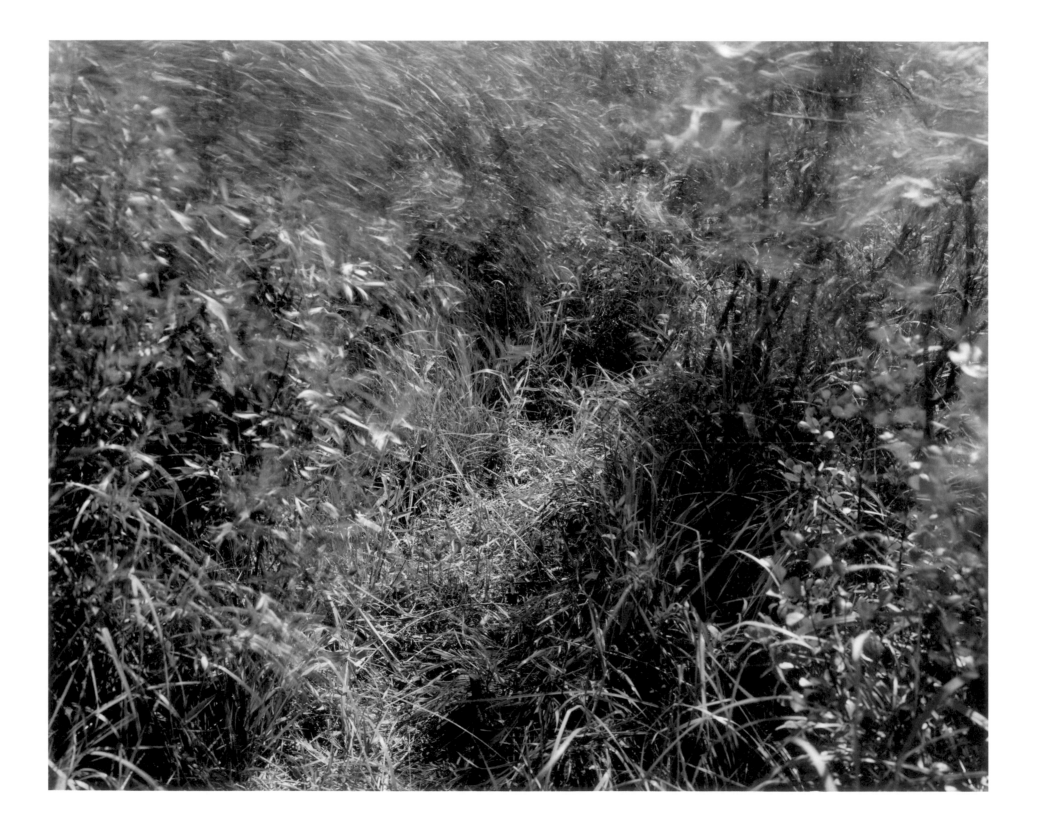

Anglers' Path Among Willows, Valley Creek, Custer County, Idaho, 2004

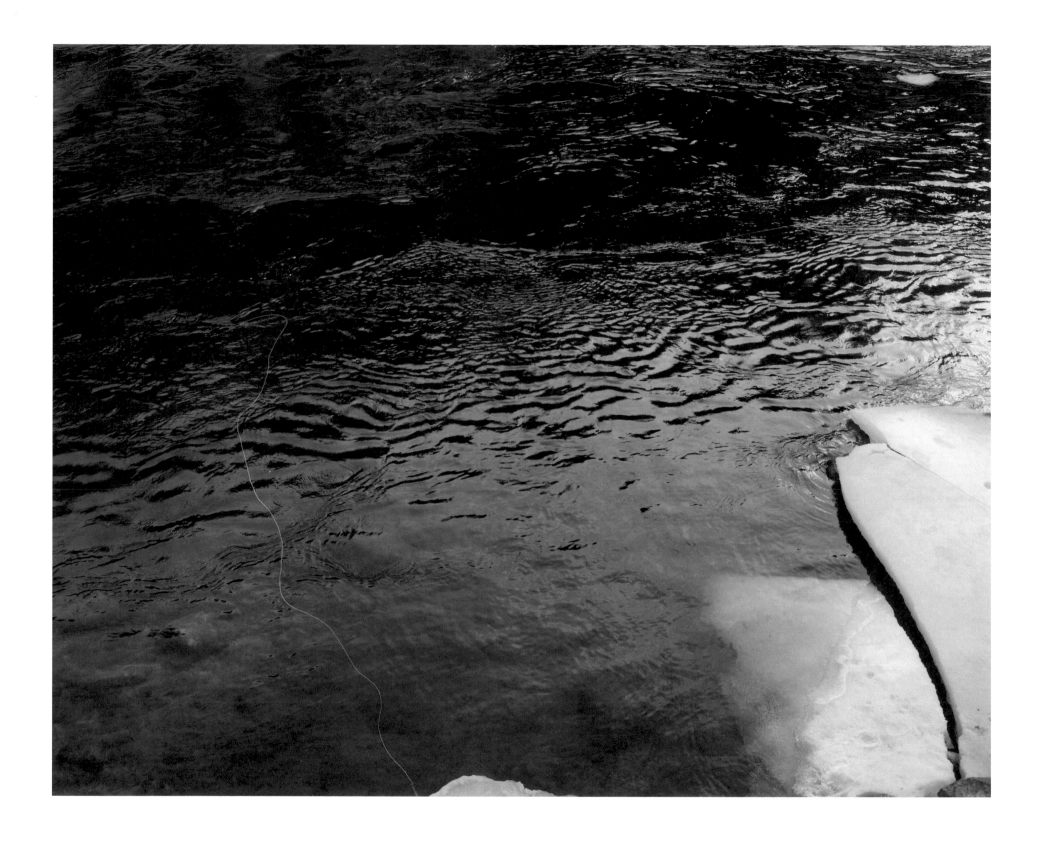

Fly Line for Steelhead, Robinson Bar, Salmon River, Custer County, Idaho, 2005

Mattie in Her Grandmother's Wedding Dress, Laverty Ranch, Custer County, Idaho, May, 2005

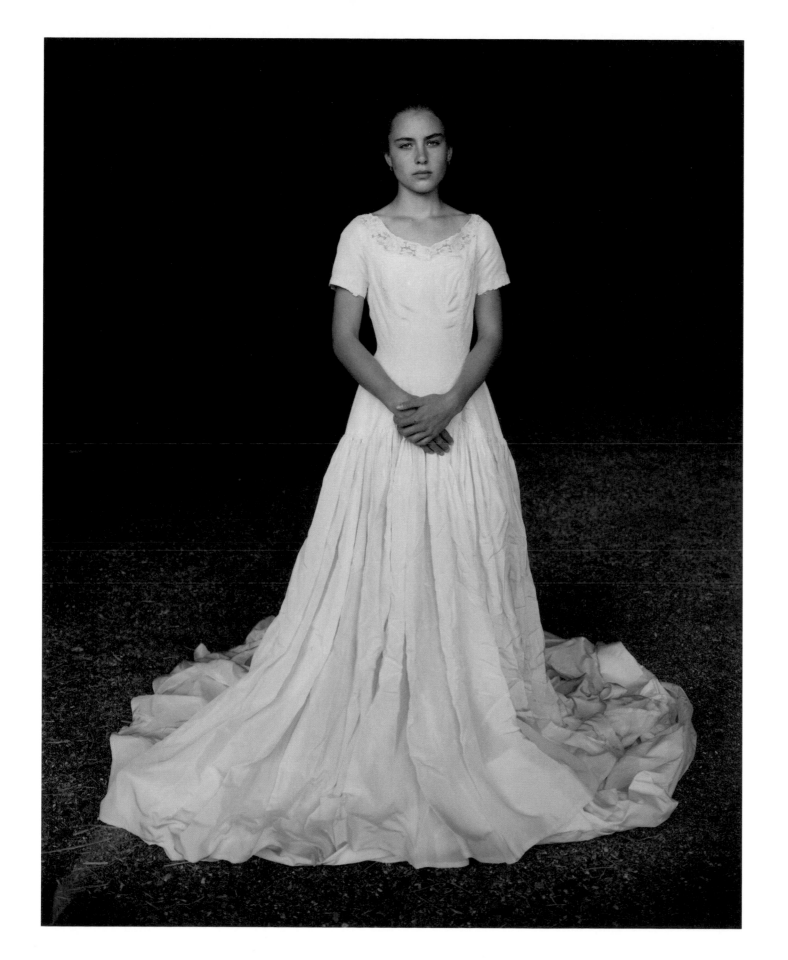

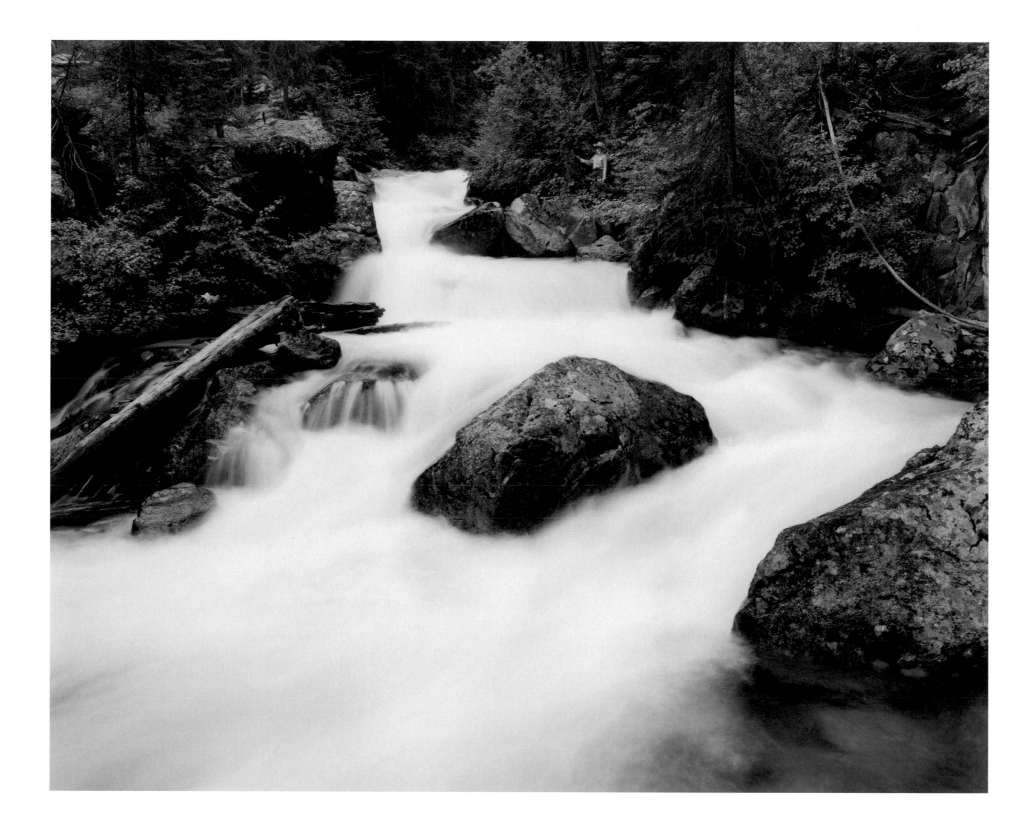

Cascade, Redfish Lake Creek, Sawtooth Wilderness, Idaho, 2004

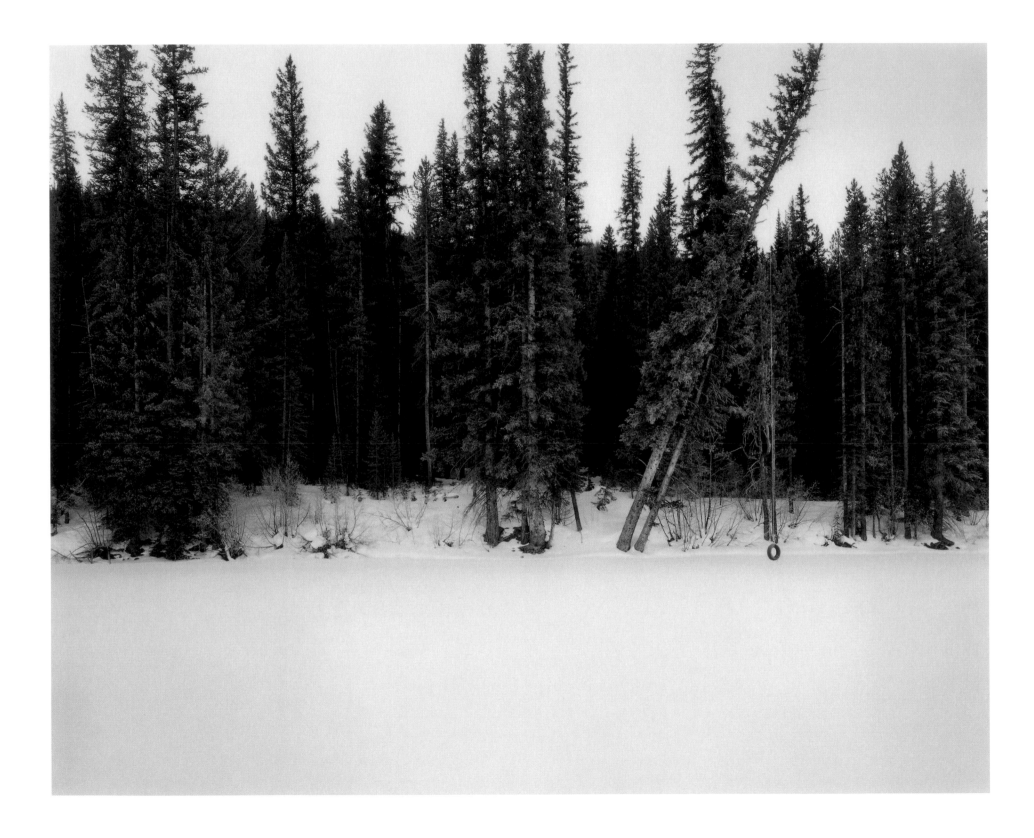

Tire Swing, Alturas Lake, Blaine County, Idaho, 2005

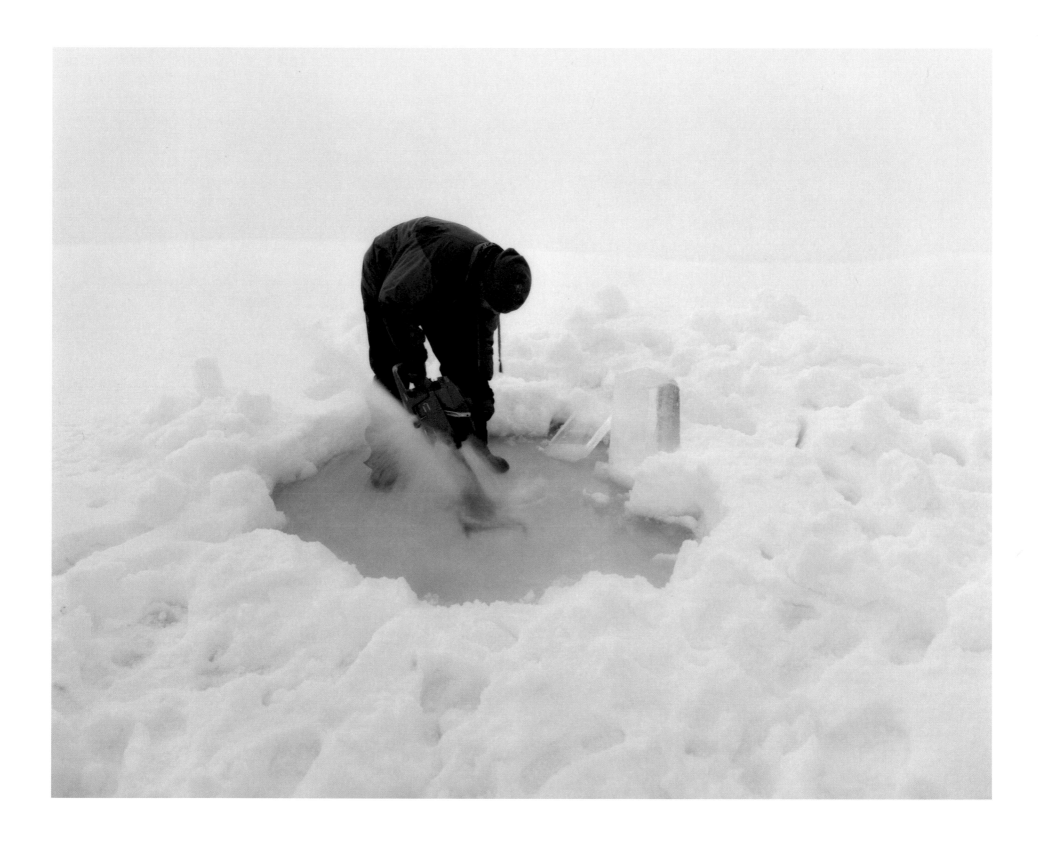

Bob Cutting Ice, Stanley Lake, Custer County, Idaho, 2005

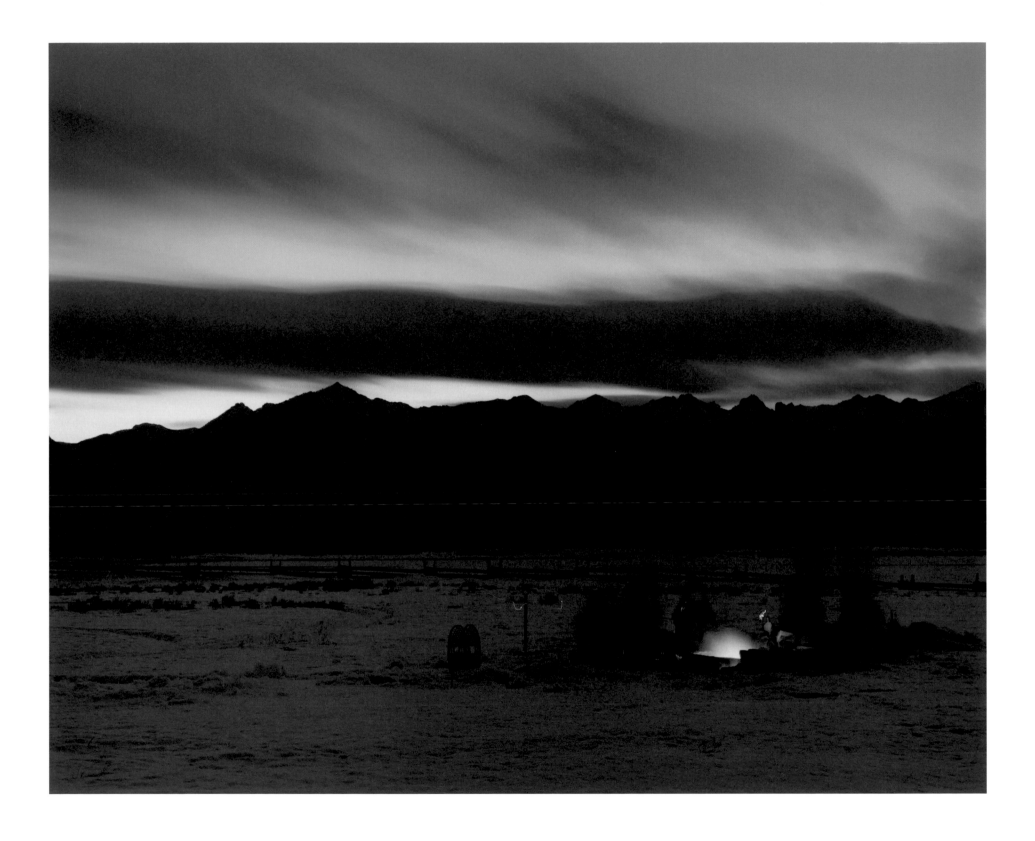

Campfire, H-Hook Ranch, Custer County, Idaho, 2004

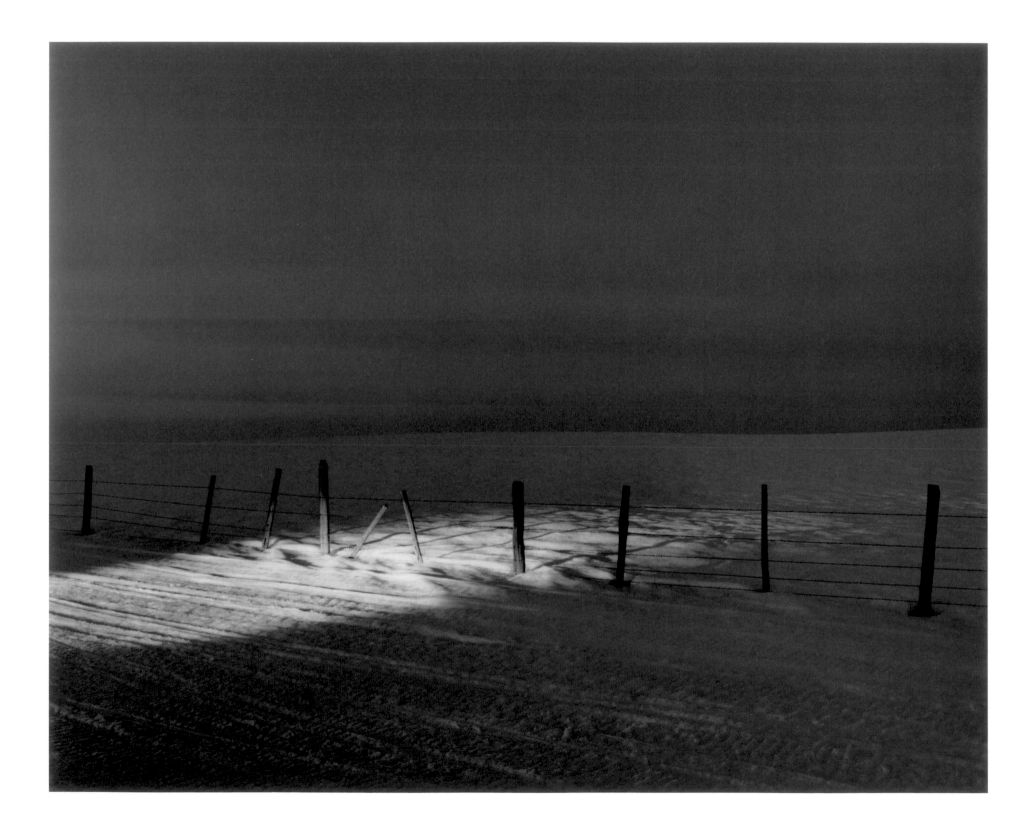

Snowmobile Headlights, Valley Road, Custer County, Idaho, 2004

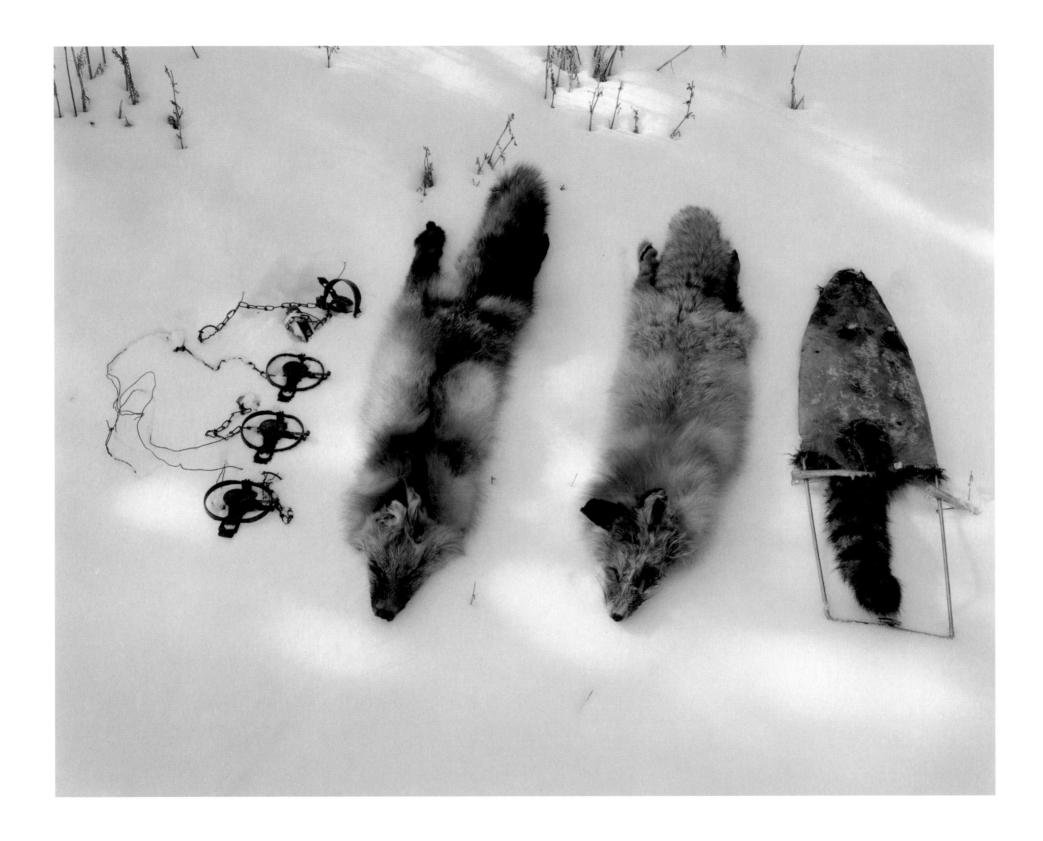

Leghold Traps and Pelts of Raccoon and Foxes, Sawtooth Fish Hatchery, Custer County, Idaho, 2005

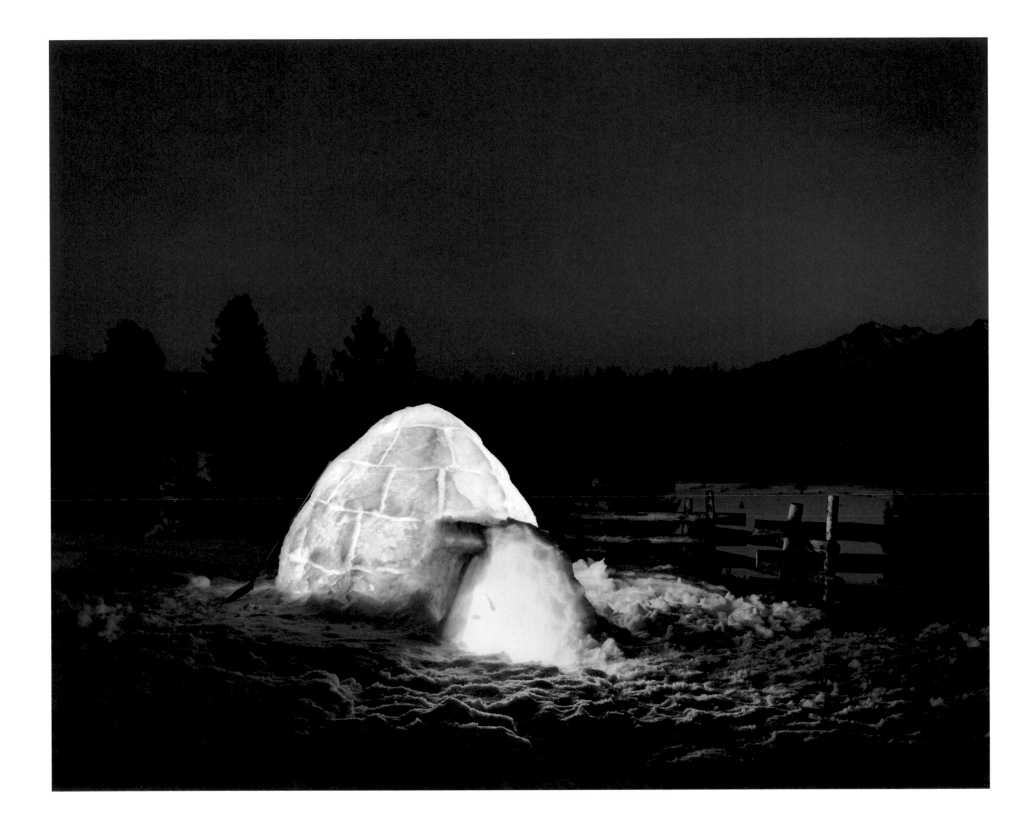

Igloo Built Following Plans Downloaded from the Internet, Park Creek, Custer County, Idaho, 2005

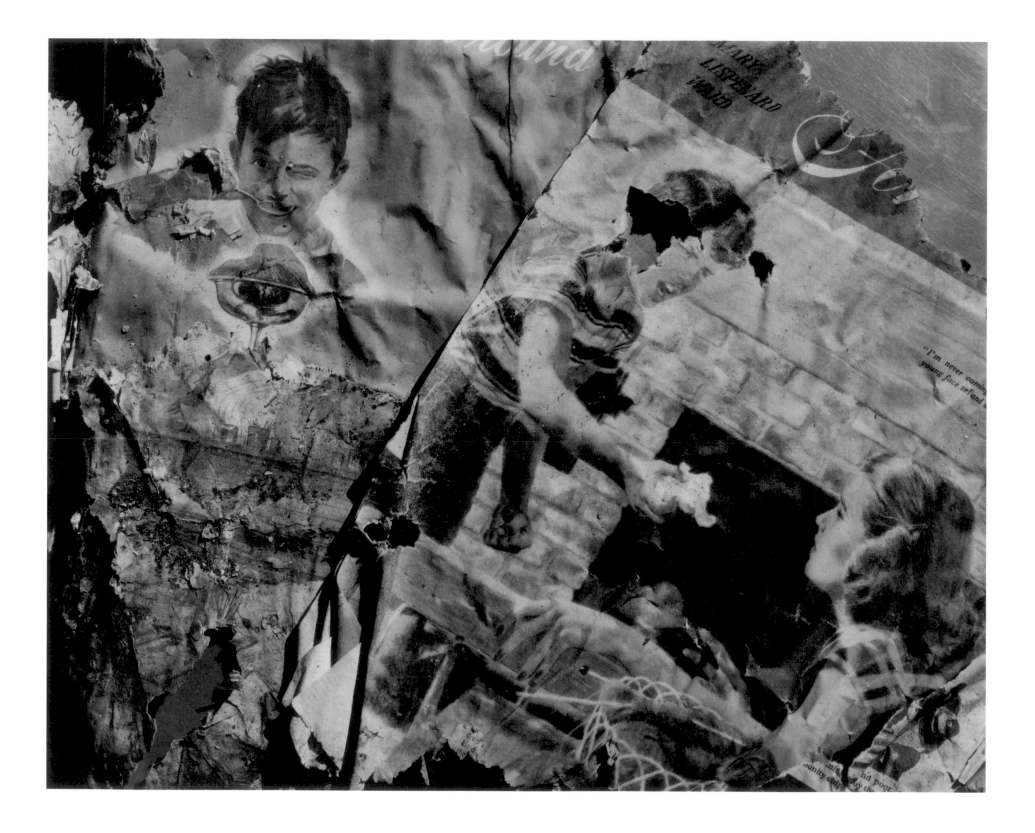

Nineteen-forties Women's Magazines at the Manager's House at Bayhorse Lead-Silver Mine, Custer County, Idaho, 2004

Judy with Elk Heart, H-Hook Ranch, Custer County, Idaho, 2004

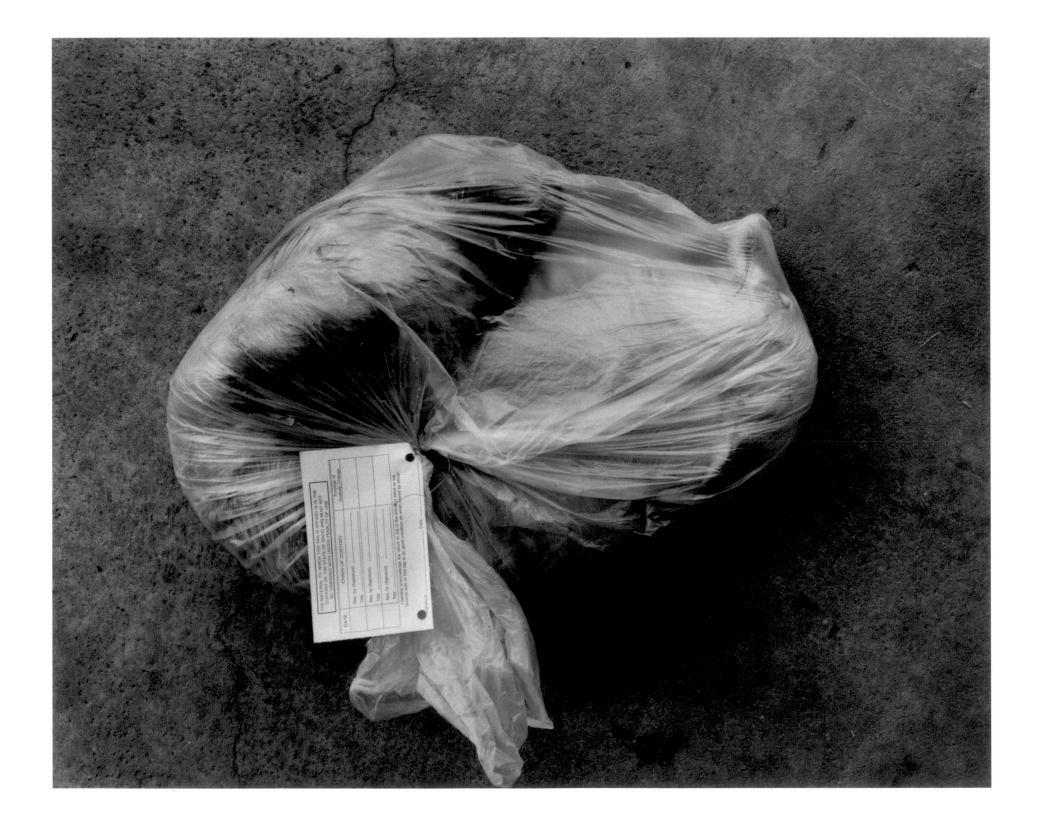

Fox Confiscated from a Leghold Trap at Rough Creek, Custer County, Idaho, 2005

Illegally Kept Snake River Chinook Salmon with Freezer Burn, Custer County, Idaho, 2005

Mattie with a Northern Red-Shafted Flicker, Laverty Ranch, Idaho, May, 2005

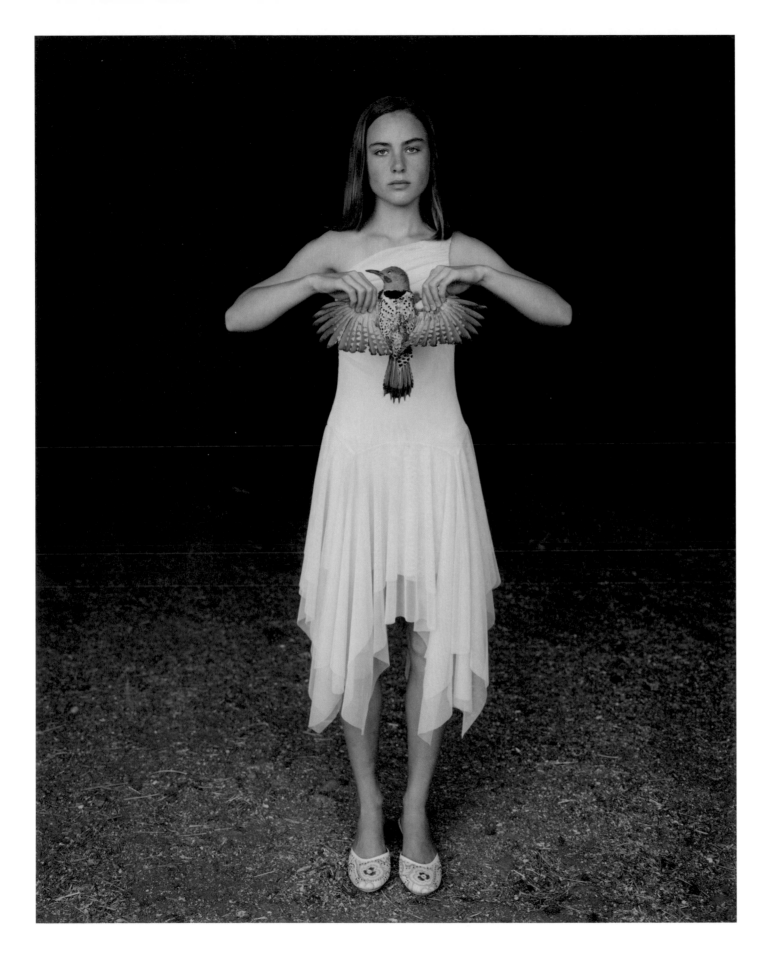

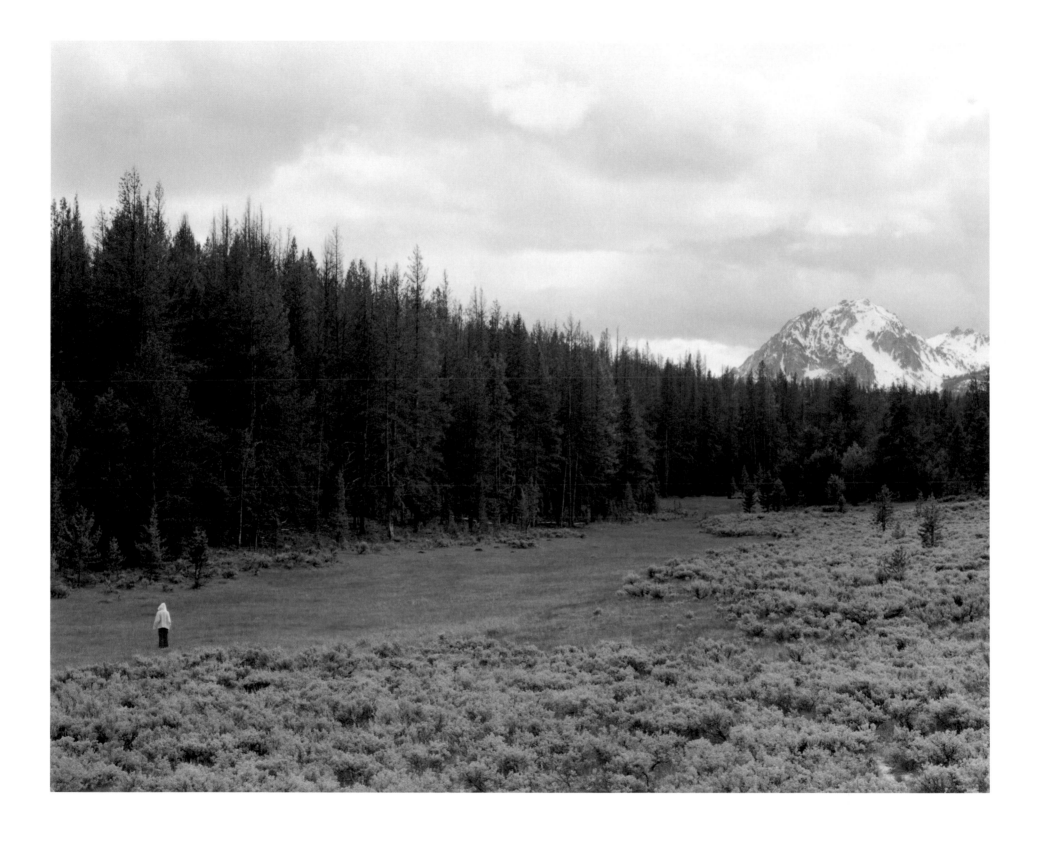

Lodgepole Pines Killed by Beetles, Nip and Tuck Road, Custer County, Idaho, 2005

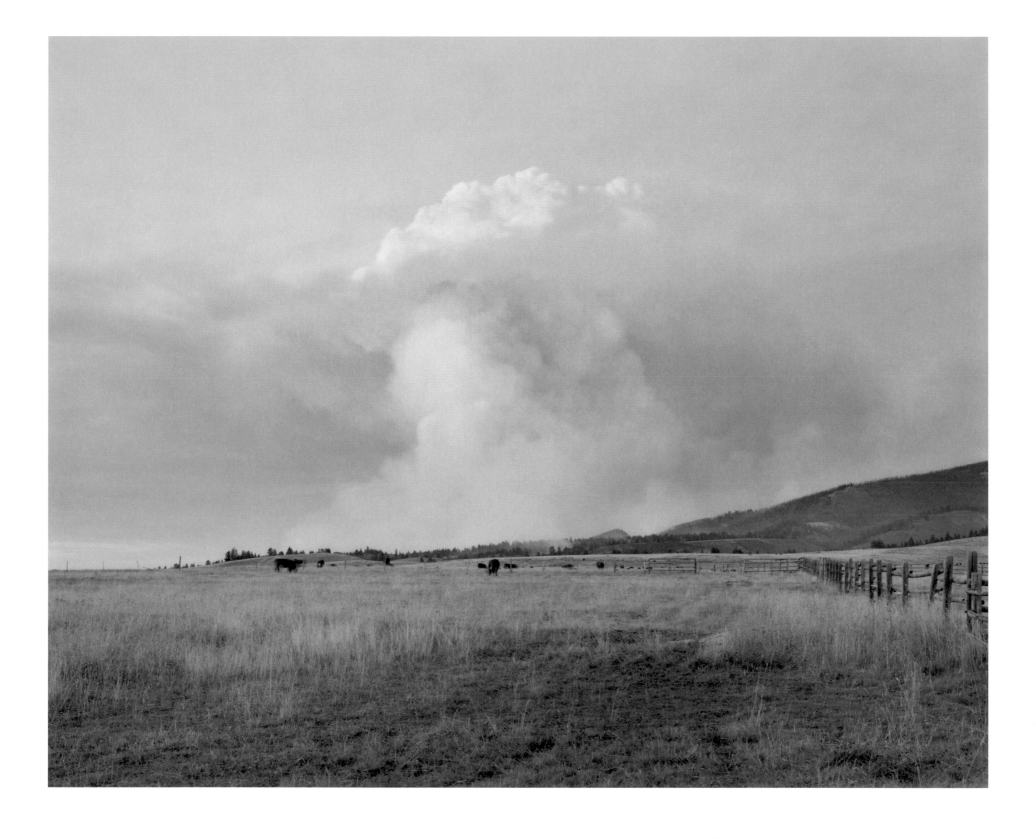

Smoke from a Wildfire Ignited by Sparks from a Burn Barrel, Champion Creek, Custer County, Idaho, 2005

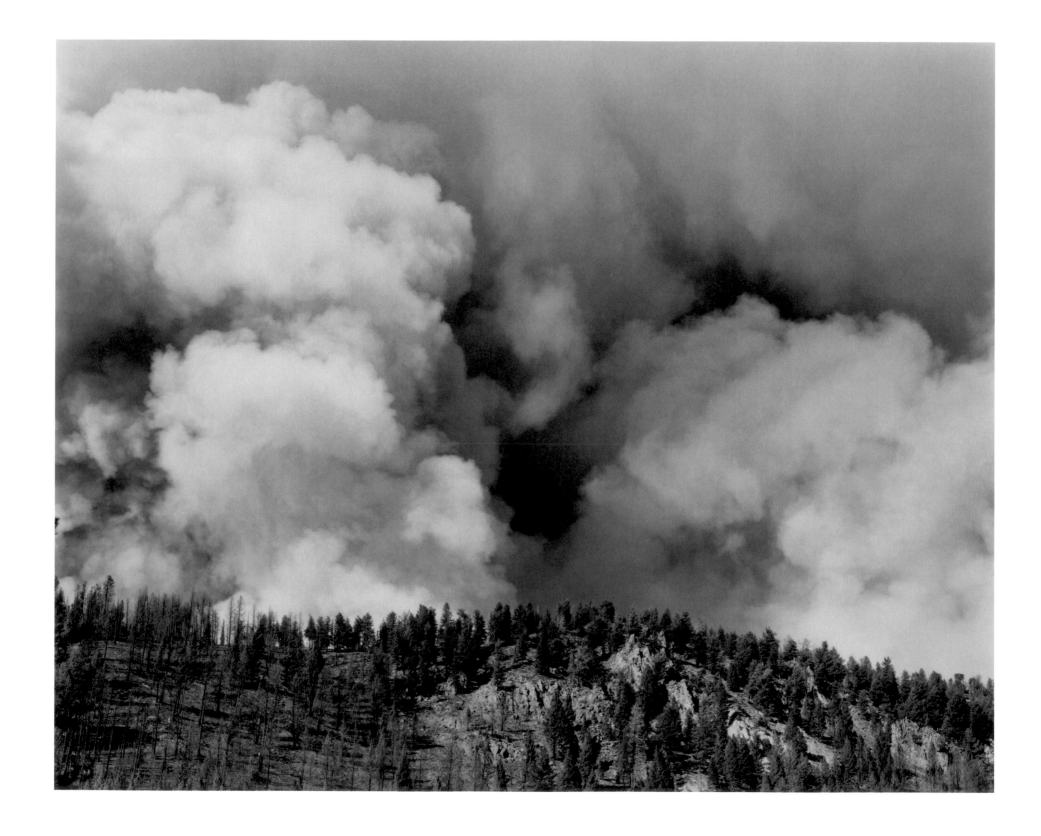

Smoke Above Fisher Creek, Valley Road Wildfire, 40,838 Acres Burned, Custer County, Idaho, 2005

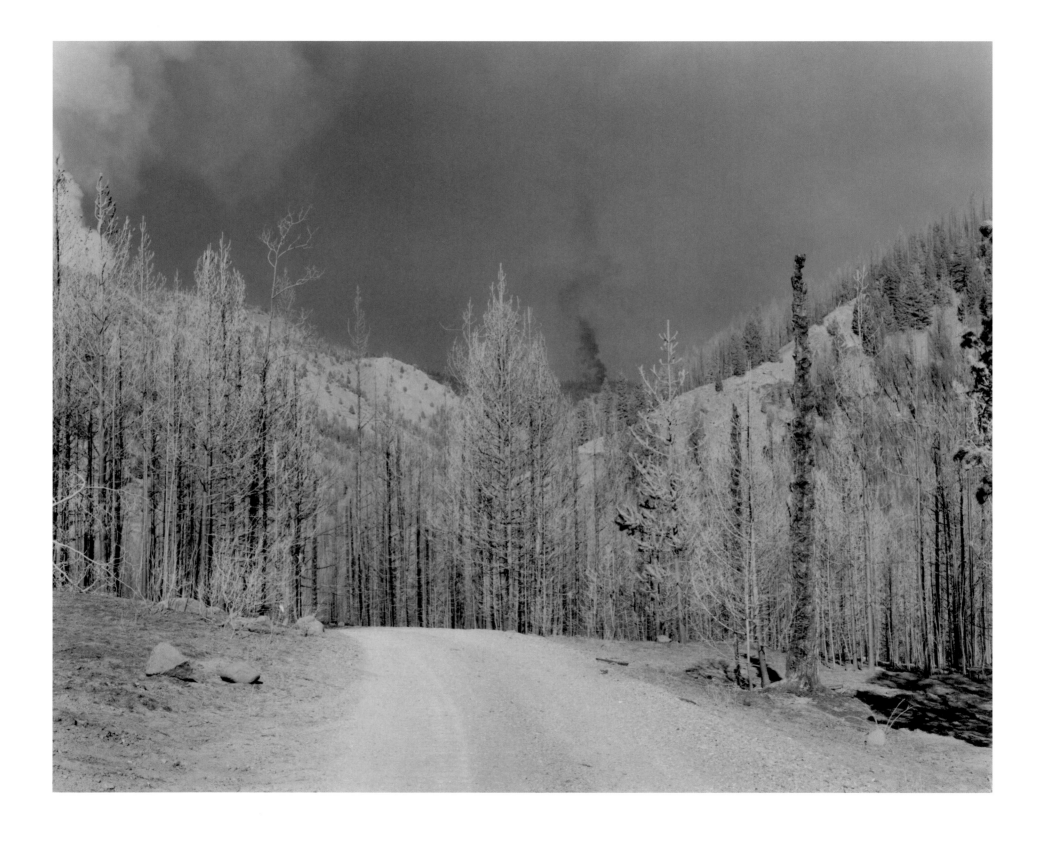

Burned Timber, Fourth of July Creek Canyon, Custer County, Idaho, 2005

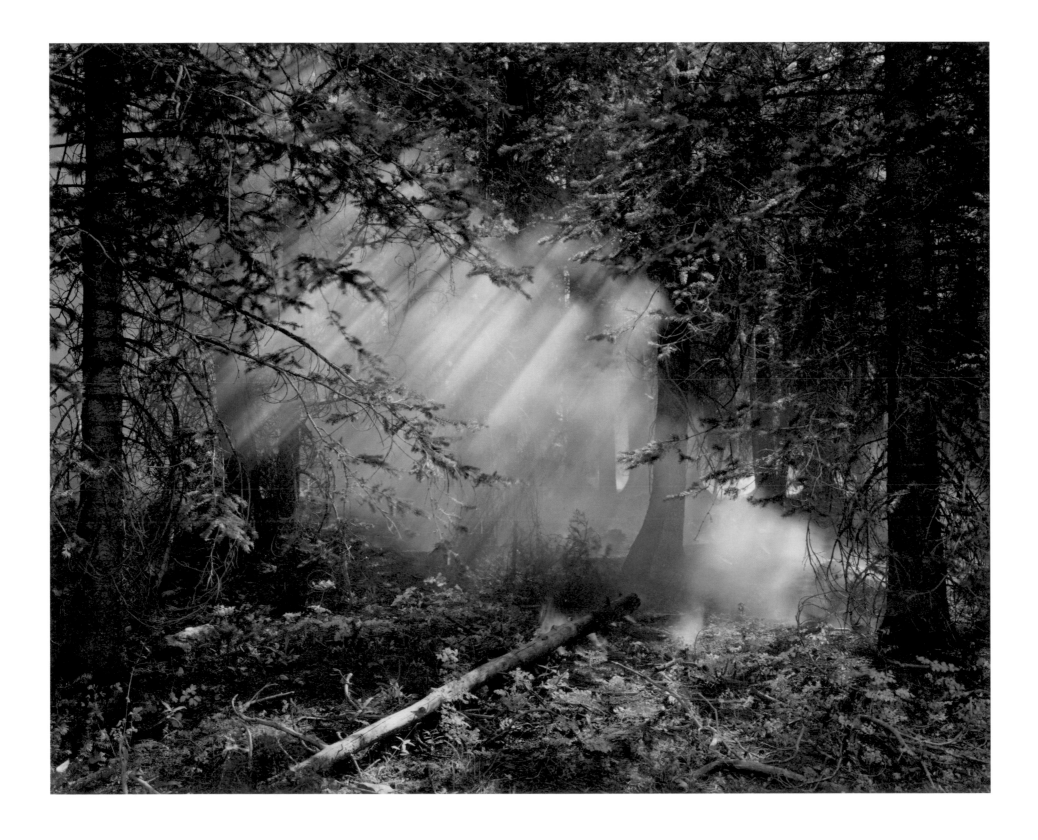

Understory Flareups, Fourth of July Creek, Custer County, Idaho, 2005

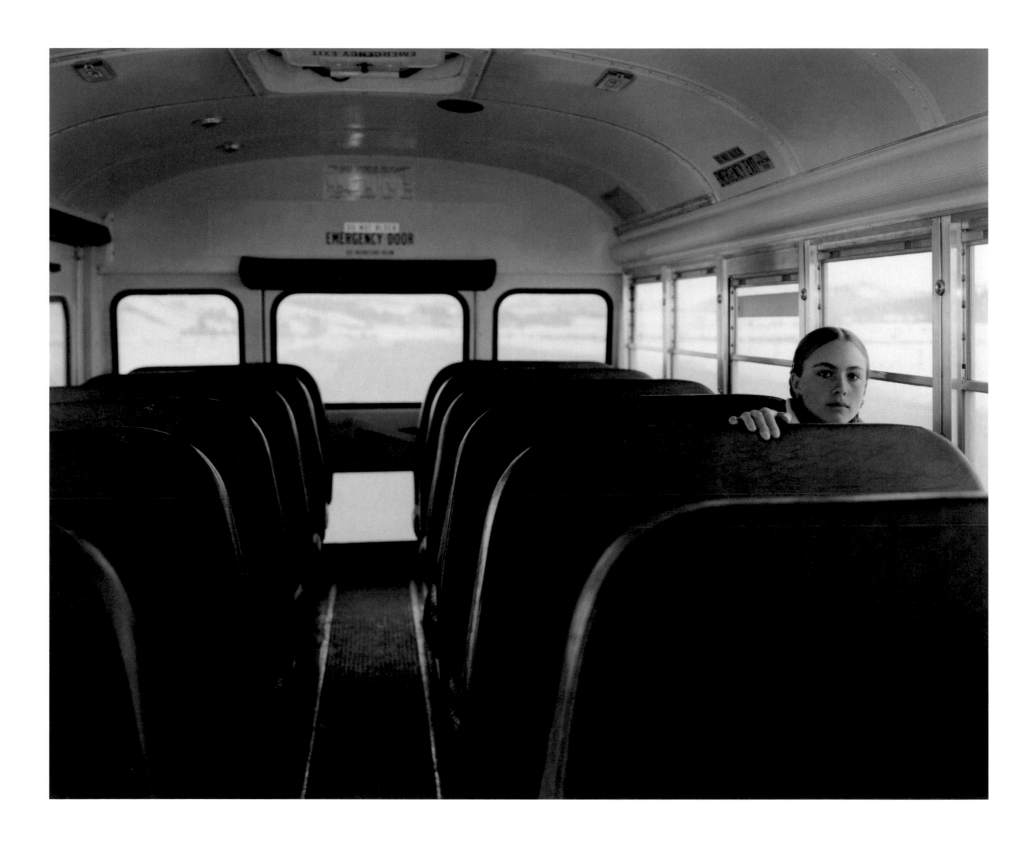

Mattie, Fisher Creek Turnout, Challis School District, Idaho, 2004

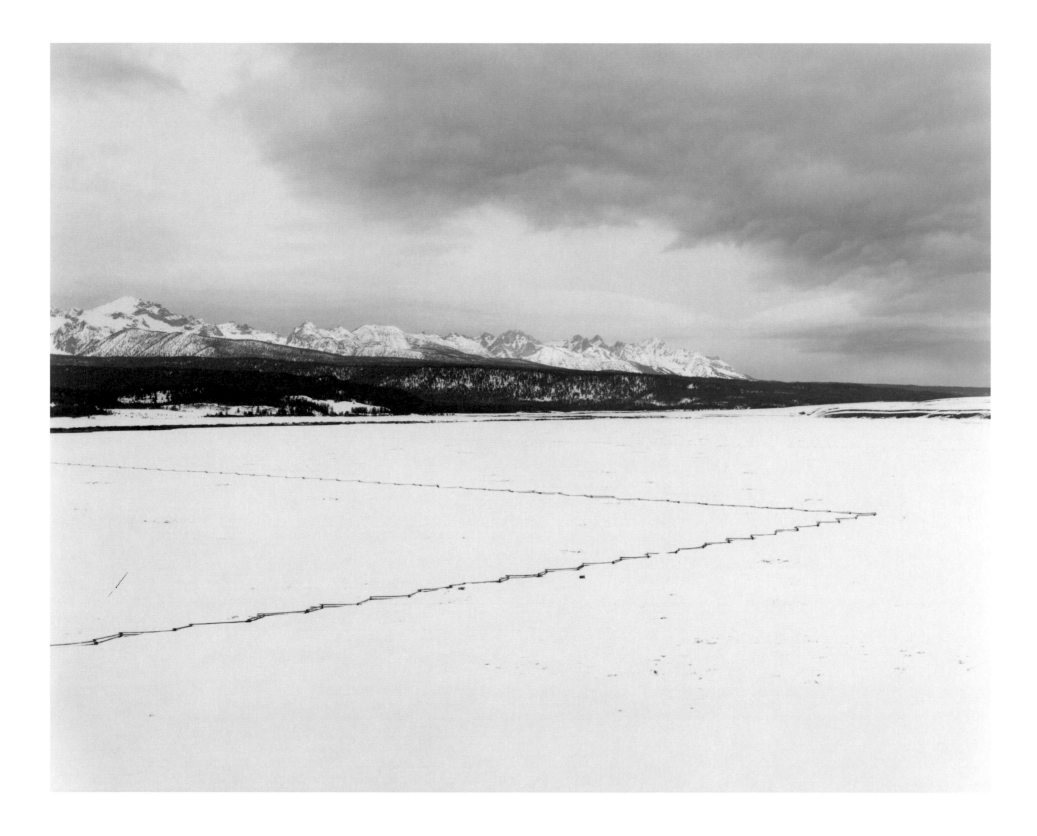

Sawtooth Range, Custer County, Idaho, 2004

Place Above All Else: Laura McPhee's *River of No Return* JOANNE LUKITSH

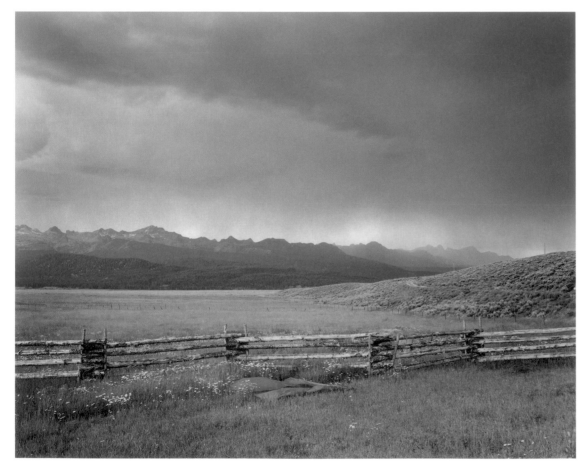

Irrigator's Tarp Directing Water, Fourth of July Creek Ranch, Custer County, Idaho, 2004

The azure cloth is an irrigator's tarp laid on the ground to direct water flowing from an irrigation ditch into the pasture. The water soaks the earth, nurturing the abundant white flowers and yellow grasses growing along a rail fence. The intense color draws a viewer's eye to the tarp, then to the angled lines of high mountains in the distance, and, finally, to a foreboding crease of darkening clouds. In the middle ground the rain falls, evaporating before it reaches the valley floor. The tarp, the wooden rails, and the fence posts are diminished in scale by the imposing mountain range and sky. This contrast of small but insistent signs of human activity against a backdrop of snowcapped mountains, great vaulted skies, and long plateaus invokes a chronicle of images of the American West, images drawn from painting and photography, Westerns and Western literature.

On the day in 2004 when Laura McPhee made this photograph, rain did not reach earth, and it hadn't for some time. Sagebrush, visible behind the fence, encroaches on the pasture. Sage prefers dry ground but does not nourish cattle. The irrigator's tarp, placed to fan water into this field to discourage sage and encourage grass, is a tiny, apparently benign gesture in the house of cards that McPhee suggests as a model to describe our relationship to the natural world. In this photograph, the first in the visual narrative of *River of No Return*, everything depends on a blue tarp.

In McPhee's photograph *Cyanide Evaporation Pool by the River of No Return Wilderness, Grouse Creek Lead, Silver and Gold Mine, Yankee Fork, Idaho, 2005* (page 19) the subject is the cleanup after a mining operation—in this case disposing of cyanide by evaporation.

In the image, white jets of mist drawn from the pool make fountains of chemicals and water. The dispersed vapors may move as widely in the atmosphere as the lead, silver, and gold extracted from the Grouse Creek Mine travel to manufacturing plants, and then to consumers, across the surface of the globe.

The frail jets ceaselessly filling the air with a haze of cyanide solution diluted by rain and snowfall are works of human design, recent additions to a long history of mining in the region. This human endeavor, though more technical than placing a tarp, appears equally inadequate to the task at hand and as dependent for success on the vagaries of wind and weather.

Landscapes, as environmental theorist and historian John Brinckerhoff Jackson long argued, are never natural, because they depict human meanings in the environment.[1] At the beginning of the twenty-first century, the scale of human transformations of the global environment is so great that these changes exceed any single mode of knowledge, or unique visionary insight. Yet the need for imaginatively understanding the interdependence of human and natural forces has concomitantly never been greater. One way of encouraging this understanding has been to recognize the importance of place, to learn how the network of history, property, culture, and personalities meshes with local material conditions and ecosystems.[2] McPhee's *River of No Return* is a photographic narrative of people and nature in a remote region of central Idaho, a place she describes as a version of America in microcosm, an area she explored for more than five years. *River of*

No Return is not, however, a report from the field, nor do her photographs make any pretense to neutrality or objectivity. Instead, through attention to structure and the accretion of telling detail, McPhee weaves a finely observed story. Her work requires the viewer to draw upon his or her own knowledge and imagination to understand the layered and intricate relations of people and nature in this environment.

Linking the landscape images in *River of No Return* are photographs of people. Most often appearing is a young girl named Mattie, repeatedly photographed standing in the doorway of the barn near her house (*Mattie with a Bourbon Red Turkey, Laverty Ranch, Custer County, Idaho, November 2004* [page 9] and *Mattie in Her Eighth Grade Graduation Dress Holding a Robin's Nest, Laverty Ranch, Custer County, Idaho, 2004* [page 59]). In the story told in *River of No Return*, Mattie is the central character, a native of Idaho during a specific time, and also an iconic figure, a twenty-first-century alternative to the cowboy of Western myth. The full-length format of these images invokes the formality of vernacular studio portraiture, except for the dust and hay on the floor and the implied presence of animals and farm implements in the cavernous space of the barn behind her (*Mattie with a Plymouth Barred Rock Hen, Laverty Ranch, Custer County, Idaho, June 2004* [page 5]). Mattie's clothes—jeans and flip-flops, a hunting jacket, a graduation dress—refer to her activities at home and at school, while she holds birds (a laying hen, a dead turkey destined for Thanksgiving dinner, a species of a woodpecker), and a nest with robin eggs, in gestures of offering to a viewer. The birds become metaphors for human relations to nature, and the photographs remind the viewer that beside such metaphors exist tangible experiences of birds as pets, as food, and as sources of feathers for adornment. *Mattie in Her Grandmother's Wedding Dress, Laverty Ranch, Custer County, Idaho, May, 2005* (page 71) directly invokes the history of her family's past and the prospects of her own future. Mattie's outlook, as our own, is bound up in environmental politics and processes—many of which are implied in the landscape she considers as she looks through the barn doors to the valley around her.

The environmental writer and theorist Rebecca Solnit observed that American landscape photography "went from the pre-historic to the a-historic," or, in other words, from the purely practical to the romantic.[3] Photography in the nineteenth-century American West typically used large-scale plates, with their extraordinary precision of detail, to describe the potential for social and commercial developments, while modernist photographers envisioned a virgin wilderness far from contemporary life. In the 1970s a number of photographers—several of them affiliated with the landmark "New Topographics" exhibition in 1975, and others with the Rephotographic Survey—made the American West the subject of their revisionist and self-reflective practice of image making. Challenging modernist visions and reflecting upon the procedures of earlier survey photographers, this generation of photographers of the West labored to evaluate the nature of photographic documentation and also the capacities for landscape images to represent the intensified development and suburbanization of the West at the end of the twentieth century. Artists such as Robert Adams, Mark Klett, Richard Misrach, Linda Connor, Barbara Bosworth, and Frank Gohlke have now worked in the region for decades, and their images have reframed expectations of how landscapes represent the actions of people.[4]

McPhee's photographs in *River of No Return* are connected to these precedents, but she also extends them. In *River of No Return*, McPhee photographed across genres, including portrait, interior, and still life, to tell a story that coalesces not only in landscape and its links to the world at large, but also in intimate descriptions of lives lived in this specific place. While her photographs compel attention through their use of light, color, form, and detail, the narrative of the book is her own invention. Without irony, McPhee acknowledges that a comprehensive documentation of the conditions in the Sawtooth Valley (and by implication anywhere) is impossible to relate. Instead, she uses photography to provoke the viewer into considering larger truths, by questioning what it is that they see in her narrative. Reading her photographs against historical precedent for photographic images of the West shows how her approach is related to these, but also how her estimation of contemporary environmental politics in the valley led to an alternate understanding of the genre and the medium.

In 1867, Carleton E. Watkins made the photograph *Cape Horn near Celilo* using a mammoth plate view camera, resulting in an image

larger than 15 × 20 in. Watkins earlier devised this format to produce images of the unique sequoia trees and rock formations of Yosemite as well as photographs of the enormous gold mining settlements north of San Francisco. He made *Cape Horn near Celilo* while following the routes of ships owned by the Oregon Steam Navigation Company as they plied the Columbia River. *Cape Horn* may well have been made on commission from the company and possibly was destined for exhibition in Watkins's San Francisco gallery.[5] The fact that *Cape Horn near Celilo* could be displayed either as an artistic view or as promotional imagery for a business speaks to the manner in which Watkins's sublime landscapes convey the power of nature as aesthetic experience and simultaneously celebrate its development as a resource. In spare, solid forms of rock, sky, river, and the converging orthogonal lines of the tracks, Watkins set the railroad's quick transit through space to the horizon against the unhurried movement of the Columbia River and its imperceptible erosion of the surrounding valley.

McPhee's *One Car Passing, Valley Road, Sawtooth Valley, Idaho, 2003* (page 3), taken on her first stay in Idaho in 2003, is amusing in its manner of measuring historical change: nineteenth-century railroads and rivers have been succeeded by cars and trucks (and unseen airplanes) as the road—rather than the river—curves around property lines delineated by fence posts. Neither dirt track nor vehicle is clearly discernible in McPhee's photograph, only their essence as traces in the dust clouds, which bisect swaths of sage, warmed by the late day sun. The car on the Valley Road is passing through, an echo of McPhee's own relationship to the Sawtooth Valley, where she began this work as artist-in-residence for the Alturas Foundation in 2003. By 2008 McPhee had made nine trips to the Sawtooth Valley. The Salmon River runs near the Fourth of July Creek Ranch, where McPhee often stayed, and numerous creeks run from the mountains to the river through ranches in Custer and Blaine Counties.

With little previous experience photographing the American West, McPhee drew on family stories about her great-grandmother, an intrepid woman who had left her husband and taken her children to live in a succession of western mining towns in the early years of the twentieth century. Imagining her grandmother, who had often recounted tales of childhood in the West, McPhee invented her own path to the area. A road sign, "Headwaters: The River of No Return,"

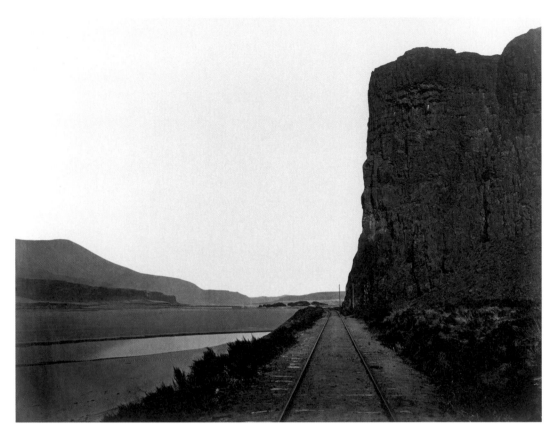

Carleton Watkins, *Cape Horn near Celilo*, 1867. Albumen silver print from glass negative, 15 3/4 × 20 5/8 in. (40 × 52.4 cm). The Metropolitan Museum of Art, Gilman Collection, Purchase, The Horace W. Goldsmith Foundation Gift through Joyce and Robert Menschel, 2005. Image © The Metropolitan Museum of Art

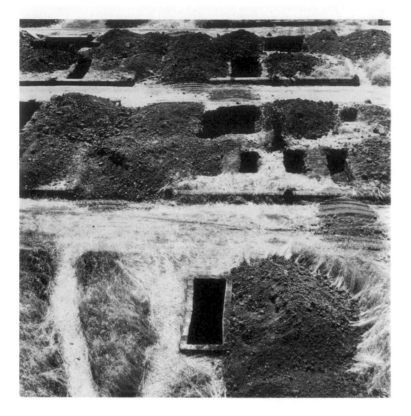

GRAVEDIGGERS CAME INTO THE VALLEY.
THEY DISINTERRED BODIES FROM THE FAMILY PLOTS
AND CARRIED THEM DOWN THE ROAD, GRAVESTONES AND ALL,
TOWARD NEW PLOTS THAT HAD BEEN PREPARED ON HIGHER GROUND. 1 4 8

Dorothea Lange and Pirkle Jones, *Open Graves, Berryessa Valley, CA*, 1956.
Taken from *Aperture* 8:3 (1960)

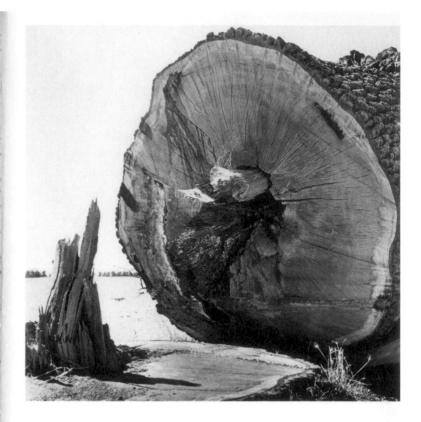

THE BIG OAKS WERE CUT DOWN
CATTLE HAD RESTED IN THEIR SHADE FOR GENERATIONS.
ON OLD MAPS AND DEEDS THEY HAD SERVED AS LANDMARKS.

marking the point where the Salmon River emerges, inspired the title. Historically, the stream's alternate name, "River of No Return," is said to refer to the fact that people in boats cannot travel back up the river once they have gone down.

Research provided clues for photographs, too: McPhee studied the social history and ecology of the region, information that shaped her curiosity about life in the valley. Through conversations with biologists, conservation professionals, mining engineers, and ranch hands, she pieced together an intricate understanding of the pressures and dilemmas facing this sparsely populated, widespread community of a few hundred individuals. Most crucially, she met a pair of scientists whose research on threatened and endangered Pacific salmon kept them in the valley, where they chose to raise their daughter, Mattie, on an isolated ranch.

In 1956 and 1957 the American social documentary photographers Dorothea Lange and Pirkle Jones visited the northern California agricultural town of Monticello and the surrounding Berryessa Valley. The United States Bureau of Reclamation had identified Berryessa as the site for a new dam, displacing its residents, and ending generations of building, farming, and community. Titled *Death of a Valley*, Lange and Jones's photo story appeared in 1960 in an issue of *Aperture* magazine, a publication dedicated to the exploration of photography as an art. Lange and Jones made their photographs to tell the story of the government's deliberate displacement of a community in order to flood the area behind a dam, and they identified with the people displaced by the project. Lange and Jones's dramatic and tersely captioned photographs of unearthed graves and felled trees were partisan images, recording a way of life literally in the process of being swept away.[6] Twenty-first-century conditions in the Sawtooth Valley in Idaho are different; the region is one of the least populated in the lower forty-eight states, and there is no pending government decision to uproot its comparatively few residents. Many of McPhee's photographs are concerned with the impact of dams on the wildlife of the region (and thus on humanity), attesting to the pervasiveness in the American West of damming rivers as, in large part, a strategy for organizing water into energy and, by implication, capital.

McPhee's photographs participate in Lange and Jones's tradition of artistic reportage, but without their advocacy for the powerless against the government. Instead, the multifaceted undertakings of scientists to mitigate the impact of dams on fish and animals are a contemporary outcome of policy that has allowed for the damming of every major river system in the lower forty-eight states. McPhee's images of the effects of dams range across artistic genres: from landscape (*Breached Dam at Sunbeam on the Salmon River, Custer County, Idaho, 2003* [page 67]) to close views of the salmon whose habitat has been disrupted (*Air Bladder of an Endangered Sockeye Salmon, Pettit Lake, Blaine County, Idaho, 2005* [page 64]), to studies of efforts to cope with deteriorating conditions for the fish (*Rob Trahant, Shoshone-Bannock Tribal Member, Counting Fish for Juvenile Chinook Salmon Survey, Valley Creek, Custer County, Idaho, 2004* [page 65]), to fantastic images—with disconcerting qualities of scale, color, and light—evoking the otherness of animals subjected to human scrutiny (*Endangered Sockeye Salmon Fry, Main Vat Room, Sawtooth Fish Hatchery, Custer County, Idaho, 2004* [page 60] and *Winter Sampling to Study Growth and Diet of Endangered Snake River Sockeye Salmon, Pettit Lake, Blaine County, Idaho, 2004* [page 63]). McPhee does not present in a heroic light these various and unlikely undertakings to preserve the salmon species; nor does she seek to engage the viewer in sympathizing with the plight of the fish. The unanticipated effects of the dam are now part of an accepted reality, and McPhee's images show the efforts of humans, in all their improbable dimensions, to deal with the consequences.

McPhee is an admirer of the photographs of Frederick Sommer, whose images and ideas had a decisive impact on the work of Emmet Gowin, her teacher and greatest influence. Raised in Brazil and educated in the United States, Sommer began making photographs as well as watercolors and drawings while recovering from tuberculosis in Europe, but his sustained work in photography began following a move to Arizona in 1931. Sommer was intellectually and emotionally aligned with metaphysical, symbolist, and surrealist ideas, and his approach to photography was intriguingly varied in genre and technique; at points in his long career he extended work in photography to other artistic disciplines, including assemblage sculpture and music. For Sommer,

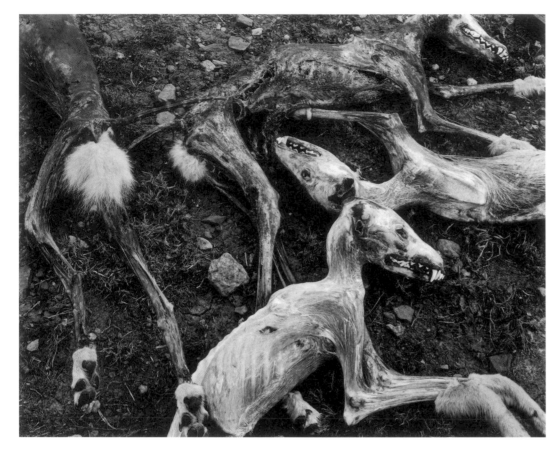

Frederick Sommer, *Coyotes*, 1945 © Frederick & Frances Sommer Foundation

photography was a medium that engaged the world: "you don't invent what you photograph. You much more yield to what there is."[7] Sommer's exacting use of photographic tone and detail rival the attention his friend and admirer Edward Weston gave to images of shells and peppers.

Unlike Weston, Sommer—in his deliberate, finely calibrated attention to the ways that things of the world could give life to ideas— took photographs of raw, conventionally ugly objects, such as a severed human leg, or chicken viscera, or, in *Coyotes* (1945), dead animals decomposing in the desert. Though the animals are dead, in their decay they seem to be merging with the dirt. Through camera angle and framing, the sharp slant of bones and smiling lines of teeth also convey animation in death.[8] In McPhee's photograph of a single dead animal, *Fox Confiscated from a Leghold Trap at Rough Creek, Custer County, Idaho, 2005* (page 84), the events leading up to the strangely tidy package of a dead fox—whose jaw distends the plastic wrapping— invokes an intricate succession of ideas about the plight of the fox, the activities of people, and judicial and economic systems as they relate to both. The fox, left too long on a trapline, was shot and confiscated by a game warden. Within a translucent bag, its warm-hued fur and tiny spots of frozen blood are visible through the plastic, as is one cloudy, unseeing eye. Unlike the elk in other images, the fox was not killed to be eaten. It is a furbearer, and its demise is determined by hunting tradition and the fur market for the fashion industry. Like the silver, gold, and lead from the Grouse Creek mine, the fox fur is a commodity from this pristine region. The miner and the jeweler, like the trapper and the fur wearer, continue traditions long practiced by humans. The photograph does not judge, but sets off concentric ripples of meaning, and the viewer must examine his or her own fascination, assumptions, and prejudices.

Sommer gave the title *I Adore You* to his photograph of a collage of images from the *Saturday Evening Post* he found attached to the wall of a miner's abandoned cabin. One of several photographs of found objects Sommer made in the 1940s, *I Adore You* is reminiscent of the Dada and surrealist collages of commercial images made by Max Ernst, Sommer's friend and fellow Arizona resident. The title *I Adore You,* borrowed from a novel by the late nineteenth-century metaphysi-

cal writer Alfred Jarry, draws attention to the experience of desire latent in the content of the images arranged by an unknown miner.[9] Sommer's intentions are emphasized in the title of the image, and also in the framing of the subject. Framing makes the man at the lower left corner a surrogate for the photographer, who coolly observes the meditation on romance and domesticity constructed by the miner. In McPhee's two photographs of images from 1940s women's magazines found in a miner's house (both titled *Nineteen-forties Women's Magazines at the Manager's House at Bayhorse Lead-Silver Mine, Custer County, Idaho, 2004* [pages 25 and 82]), the possibilities of chance juxtapositions of found content are inseparable from signs of the workings of time: moisture rolls the papers' edges, heat warps the surfaces, while bright sunlight throws some details into impenetrable shadow. By framing the contents at a pronounced angle, McPhee imposes an order on the collages, but her understanding of the operations of chance builds on Sommer's work with the metaphysical and marvelous. Desire is still at play: women subscribed to these magazines to bring information and entertainment from the outside world into their lives as homemakers in this isolated region. McPhee's rendition of these pages speaks to their owners' longing for experiences outside the confines of place.

As the title of Sommer's photograph, Jarry's phrase "I Adore You" became another piece of the collage, suggesting directions for looking at the contents of the magazine illustrations and their juxtapositions of imagery. In contrast, McPhee's titles are factual, but their contents are not straightforward: the pool contains cyanide, the igloo is made from plans downloaded from the Internet, gigantic rocks are destined for landscaping in Sun Valley, a hunter in camouflage is tranquilizing, not shooting, wolves, and dark russet pine trees are infested with beetles. McPhee's titles are often startling as descriptions of the familiar iconography of natural resources and human activities long associated with the American West.

Robert Frank's unique combination of social commentary and art in his 1959 photographic book *The Americans* has become a touchstone for generations of photographers.[10] The final image of Mattie, alone on a bus (*Mattie, Fisher Creek Turnout, Challis School District, Idaho, 2004* [page 97]), in *River of No Return* is McPhee's homage to the

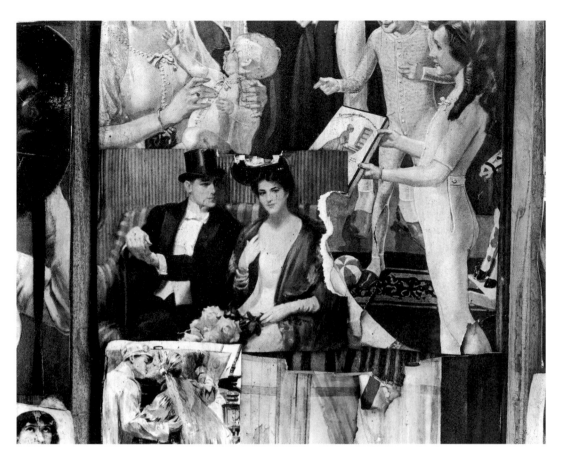

Frederick Sommer, *I Adore You*, 1947 © Frederick & Frances Sommer Foundation

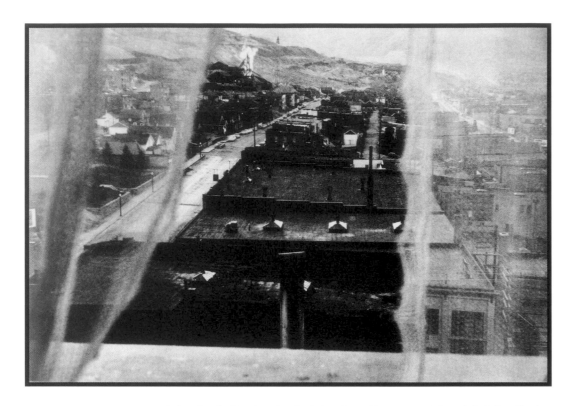

Robert Frank, *View from hotel window, Butte, Montana*, 1956. Copyright Robert Frank from *The Americans*

photograph of Frank's wife and children in their car in the final image of *The Americans*. Mattie's solitude distinguishes her from the children in Frank's image as she sets out on her journey alone. Frank's photographs reflect upon his experiences and his process of discovery on a journey. His photograph *View from Hotel Window, Butte, Montana* draws upon a trope of romantic art, the window at once a threshold and a barrier, an invitation to participate in the world and a reminder of the comforts of remaining inside.[11] The bleak streets of the town in Montana are an unappealing prospect, and while the delicate pattern of the curtains promises some solace, Frank, of course, did not remain indoors.

McPhee's six photographs of the Fourth of July Ranch, taken over five years (pages 39, 40, 41, 42, 43, and 45), the view from the porch on the ranch where she stayed most often during her residency, are most like traditional landscape views of the region, with their changing effects of weather measured in photographs of distant mountains, vast skies, and the great expanse of land. Within *River of No Return* we learn that this land is the site of irrigation activity, that the traditional fence in the foreground is one of many—fences separating private and public lands, cattle and wolves, cattle and humans, sagebrush and grass. In the center of the book, this sequence of images emphatically depicts cycles of natural change, while also making inescapable the deep inscription of human use on this place. Unlike Frank, whose project took him around the United States, McPhee repeatedly returned to the Sawtooth Valley. Her six photographs of the view from the porch narrate her developing relationship to the area. While her photographs, like romantic landscapes, invite the viewer's emotional identification, the evidence everywhere in her photographs of the politics of place draws the viewer into the here and now. McPhee resists an ideological voice for *River of No Return*. Her photographs of people in the valley are consistently sympathetic, yet we see that the effects of human actions on the environment are complex and subject to multiple interpretations. Even in the aftermath of a devastating fire, set off by human accident, nature's capacity to renew itself is asserted in the book's closing images, while the stands of black, burnt trees suggest human figures, whose return will soon be registered on these spaces.

In McPhee's descriptions of the relations between individual and collective, science and belief, industry and imagination, *River of*

No Return narrates a story of a specific place in the twenty-first-century American West. While her images resonate with the myths and icons of this region, they make new demands on the imagination of the viewer. Photographs are inscribed with the lost moment of their making, but McPhee understands the desire photographs generate as the necessary condition for their creation. In her approach to photographing place, McPhee deliberately calls upon the capacities of photographic images to describe, organize, conceal, and evoke the processes of nature and the activities of people. McPhee's photographs in *River of No Return* do not magically turn the human meanings of this environment into new forms of landscape. Instead, her photographs set forth the necessary conditions for creation in the response of the viewer, who needs to take the measure of one place to better imagine a different experience of his or her own.

NOTES

My thanks to Patricia Johnston, Martha Buskirk, and David Harris for their comments on this essay.

1 John Brinckerhoff Jackson, *A Sense of Place, a Sense of Time* (New Haven: Yale University Press, 1994), vii.

2 Lawrence Buell, *Writing for an Endangered World: Literature, Culture, and Environment in the U.S. and Beyond* (Cambridge, MA: Belknap, 2001). See also *Aperture* 150 (Winter 1998); this issue is titled "Moments of Grace: Spirit in the American Landscape."

3 Rebecca Solnit, *As Eve Said to the Serpent: On Landscape, Gender, and Art* (Athens, GA: University of Georgia Press, 2001), 91.

4 Peter E. Pool, ed., *The Altered Landscape* (Reno and Las Vegas: Nevada Museum of Art, with the University of Nevada Press, 1999). See also Whitney Museum of American Art, *Perpetual Mirage: Photographic Narratives of the Desert West*, organized by May Castleberry (New York: Harry N. Abrams, 1996); and Mark Klett (chief photographer), Ellen Manchester (project director), JoAnn Verberg (project coordinator), and Gordon Bunshaw and Rick Dingus (project photographers), *Second View: The Rephotographic Survey Project* (Albuquerque: University of New Mexico Press, 1984).

5 Mary Warner Marien, "Imagining the Corporate Sublime," in *Carleton Watkins: Selected Texts and Bibliography*, ed. Amy Rule (Boston: G. K. Hall, 1993), 9–13.

6 Linda A. Morris, "A Woman of Our Generation," in *Dorothea Lange—A Visual Life*, ed. Elizabeth Partridge (Washington and London: Smithsonian Institution Press, 1994), 26–28. See also Pirkle Jones, *California Photographs* (New York: Aperture, 2001), 26–43.

7 *The Art of Frederick Sommer: Photography, Drawing, Collage* (Prescott, AZ: The Frederick and Frances Sommer Foundation, and New Haven: Yale University Press, 2005), 210.

8 Keith F. Davis, "Living Art: The Sources of Frederick Sommer's Work," in *The Art of Frederick Sommer*, 18.

9 April Watson, "Sommer Chronology: 1905–2005," in *The Art of Frederick Sommer*, 224.

10 Robert Frank, *The Americans: Photographs* (New York: Grove Press, 1959; rpt. New York: Pantheon, 1986). See also W. J. T. Mitchell, *What Do Pictures Want? The Lives and Loves of Images* (Chicago and London: University of Chicago Press, 2005), 272–93.

11 Lorenz Eitner, "The Open Window and the Storm-Tossed Boat: An Essay on the Iconography of Romanticism," *Art Bulletin* 37 (December 1955): 281–90.

An Interview with Laura McPhee

DABNEY HAILEY

114

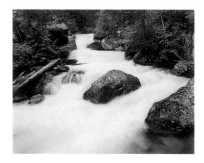

McPhee's Grandmother and Her
Younger Sister Photographed
in an Unknown Portrait Studio,
ca. 1914

DH How did you find yourself in the Sawtooth Valley in Idaho?

LM The Alturas Foundation asked if I would be interested in
a residency in central Idaho. I was to visit four times across one
year for a couple of weeks at a time. Initially, I felt some trepi-
dation about taking the residency though there were no spe-
cific requirements attached to it. By the end of the project I had
visited nine times over five years, from 2003 to 2008.

DH Why trepidation?

LM That part of Idaho is very picturesque, it's emblematic of what the
West looks like in the popular imagination: tall mountains, a
valley, a river runs through it. My concern was that I was going
into a world that was well defined in the work of artists like
Ansel Adams. I wasn't sure that I would have a lot to add to the
dialogue about place that had already occurred in the history
of photography in the nineteenth-century—photographers like
Edweard Muybridge, Timothy O'Sullivan, Carleton Watkins—
all of them described the West. They were on the upward curve
of manifest destiny.

DH And where are you on that curve?

LM I think we've come over the top, and the roller coaster is
headed in a different direction. Gravity is pulling us. Still,
most Americans have some notion of what the West looks
like and what it represents. The myth of a big open space
where the deer and the antelope play is part of our collective
imagination even if, in reality, most of that space now has
cul-de-sacs on it. The series of photographs that I found myself
making considers conflicting, paradoxical ideas about land-
scape in America and about values and beliefs concerning the
natural world.

DH You bring the photographic dialogue about the American West
into the twenty-first century. What was your initial response to
the Sawtooth Valley?

LM I had the reaction that I always have when I arrive someplace
and want to make pictures: I panic. And then, as I relax, I meet
people and I imagine myself into the environment, through
a combination of research, and intuition, and sensitivity to the
visual world.

My personal route into the Western landscape was through
my grandmother and the stories she told us as children. She
always wanted to write a book called *Sweetpeas and Rattlesnakes*.
At any rate, her mother, my great-grandmother, Glenna Ideallia
Stewart, was a restless person. That runs in the family. Sometime
around 1912 she decided she'd had enough of married, Midwest-
ern life. She got on a train and went West with her two young
daughters, leaving her husband in Ohio. Glenna became an itin-
erant schoolteacher working mostly in mining towns in Montana,
Nevada, Idaho, Oregon, and Washington. She'd often leave her
two children for weeks at a time in a log cabin outside of town
with a gun and some supplies.

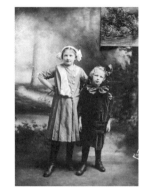

115

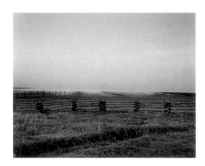

DH She was the female version of some Western archetypes—the explorer or the loner.

LM Yes, absolutely. Even before I left Massachusetts for Idaho, I started to imagine my grandmother's childhood and what the West would have meant to her. I read about girls and women living as they did. When I arrived at the local airport to begin my residency, I was driven to the Sawtooth Valley in a white Suburban, not exactly how my grandmother would have traveled. We stopped at eight thousand feet, at an overlook on Galena Pass, and stood taking in the view. I envisioned my grandmother standing in such a place, and I thought about how different her experience must have been, how she might have been exhausted from hours of walking or riding. As we drove down to the valley floor, we passed a small brown Forest Service sign which read, "Headwaters, River of No Return." I wrote it down, *River of No Return*.

I thought then that her subjective experience was lost to me, that actually we only get glimmers of one another in any case. But still, she could stand beside me there. This is one of the things that so compels me about photography: the medium has the ability to appear to fix fact and time, but you are aware it is an illusion, that time marches on and meaning and truth are momentary and elusive.

DH Yes, photography can be overwhelmingly reflective in the sense that the moment it captures is only retrievable through the fragment of the picture: there is no return. Yet on the other hand, your work has an overtly political edge as well, one rooted very much in the present time and current debates around mining, dams, global warming, and the management of species. It makes visible the tension between the natural world, or the world as we humans find it, and how we are currently trying to shape and control it.

LM We are nature, but we tend to see ourselves outside of it. We are the vines growing around the tree. In my work I look both at the ways that we exploit nature and also the ways in which we attempt to preserve it.

DH What is a landscape, for you?

LM I like J. B. Jackson's ideas. In his book *Vernacular Landscape*, he tells us that the dictionary defines landscape as "a portion of the land which the eye can comprehend at a glance." The word was introduced into English in the seventeenth century as a way to talk about an artist's interpretation of a view.

But if you go further back (as Jackson does), to the Gothic meaning, you find that *land* denoted a plowed field. The second syllable, *scape,* meant a collection of similar things. So it seems that landscape was understood as a collection of lands, or, in other words, an assemblage of spaces on the land organized by people. He also writes, and I love this, that landscape is "a space deliberately created to speed up or slow down the process of nature . . . it represents man taking upon himself the role of time."

DH One way to frame the *River of No Return* photographs is as a multifaceted, ambitious narrative in pictures, with intertwining plots, settings, and characters. Which of the Valley's stories emerged first as you came to know this place as it is today?

LM An overarching story is the impulse to manage the natural world: this is something particularly human, of course. We weave ourselves an impossibly intricate web. In the Sawtooth Valley, people are living—have very consciously chosen to live—at the edge of what is habitable. Even the Indians only used it as summer hunting ground. It's high; it's dry in summer, and during winter it snows incessantly and temperatures can drop to fifty below. Snowfall might occur in any month of the year, including July. Wolves visit the front yard and the chicken coop. Elk and antelope on the hillside can mean food during hunting season, but, at other times, people find themselves feeding the elk. The tiny population—only a few hundred people in the Sawtooth Valley— as well as government agencies argue over every aspect of the management of the land and the species that dwell there, including the humans.

DH Why are they so divided?

LM People divide over the best methods for management, in part because they have different ideas about what constitutes the ideal

landscape and how that land should be used. Is it a landscape that includes ranching and is thus irrigated? Or should it be in its natural state, full of sagebrush and aspens and camas lilies? Do wolves belong back in these parts because they were once here? And now that they've reproduced enough by some people's standards, is it right that they should be hunted again? Should grizzlies be reintroduced? They were once here, too.

DH How did you go about making images of the landscape in this part of the country, and how did you find that reflected in the questions raised as you worked?

LM I was surprised to discover that though I was in my own country, I was in a new culture—a place where animals far outnumbered people, a place of intense beauty and severe weather, a place where some species lived in abundance and others were on the verge of extinction. In aggregate, the photographs pose many questions. First, of course, each asks, what is it exactly that I am seeing and on what levels do I understand it? Then there are the facts of each image, about which I can tell you a lot and which are referenced in the titles, but there is also the presence of beauty and metaphor, which are every bit as important, though harder to relate in words. Each photograph has to marry all those elements together.

DH Let's look at *Winter Sampling to Study Growth and Diet of Endangered Snake River Sockeye Salmon, Pettit Lake, Blaine County, Idaho, 2004.* This picture beautifully combines the two primary concerns of your work: the image provides immense, specific detail but translates those facts into metaphor, like a visual form of the literary genre of magic realism. From what I understand it's a scientific procedure—but I've also heard you compare it to an image of outer space.

LM This photograph was made on a very cold day in March on Pettit Lake. Scientists put gill nets down a long trench that they cut through a couple of feet of ice with a chain saw. They examine the stomachs of the captured sockeye salmon, an endangered species, to see what they've been eating and to find better ways to get nutrients to them. These fish are wintering over their first year

and are very tiny, only about four inches long. What you see in the image is the fish with their stomachs removed for study. They were thrown back but fell onto a very thin layer of ice that formed in the open trench. So the camera is looking into the abyss, but also the sun is refracting countless times in the ice itself. There are a million little suns in there. As a result the fish appear to be in a dark sky, amid constellations, or a galaxy. And at the same time they're part of a scientific study.

DH These tiny fish represent a dying species and the whole universe at once.

LM The story of the Snake River sockeye is the double-edged sword you find everywhere in the Sawtooth Valley, in any environment these days, really. The salmon leave the lakes when they are not much bigger than the ones in the photograph. They swim nine hundred miles to the Pacific, crossing eight dams, four on the Snake River and four on the Columbia River, and through four hundred and fifty miles of slack water, the water behind the dams. They spend two years in the ocean, where they grow to twenty inches, and then they make the return journey, finding first the Columbia, then the Snake, then the Salmon River and return to the lake where they originated. That same season, they spawn and die. Before the dams, they returned in such profusion that it was said that you could cross the river on their bodies. Now, the dams interrupt their journey. Only a few return; some years there are none at all.

DH Is it even possible to save them, as the fish biologists are attempting?

LM That's not clear, but the government, which owns the dams, also spends large sums of money to conduct studies, build fish ladders, put nutrients in lakes, and build hatcheries in which genetically compromised fish are raised. We want the fish to survive. And we want to flip on our hydro-powered electric lights. We're walking a fine line, trying to have things both ways. It's that prismatic, paradoxical effect. How do we hold conflicting desires in our heads or in a photograph at the same time? As we control and manage streams and rivers and species right out of existence in the interest of electricity and ranching and recreation and so forth, how

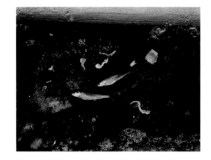

do we make peace with these decisions? How do we get what we believe we need yet protect the world that sustains us simultaneously? We face these ideological battles no matter where we live, but in the microcosm of a place that seems untouched, such as this idyllic, protected valley, these issues stand out in sharp relief.

DH It's a complicated web of choices.

LM Each choice shadows another choice and implies five more, and unintended consequences often follow each decision.

DH Let's look at another image, *Judy Tracking Radio-Collared Wolves from Her Yard, Summer Range, H-Hook Ranch, Custer County, Idaho, 2004.* This one has to do with the reintroduction of wolves to the West. What was compelling about that situation?

LM Wolves were brought back to Idaho about ten years ago. Before 1950, wolves were hunted out by ranchers essentially because they eat sheep and cows. Environmentalists wanted to reintroduce wolves because they value the idea that at one time the West was intact in its ecology. Now we have altered things—changed the surface of the land, changed the relationship between one species and another. So some are trying to turn back the clock. The question is, what point in time do you choose? Environmentalists and ranchers see this very differently—and they are at each other's throats over it—quite literally. Just now the state of Idaho has made it legal to hunt wolves again.

In the image of Judy in the field, she's standing outside her house using a radio and an antenna given to ranchers by the government in order to help reduce wolf/livestock conflict. Every day she listened with this equipment to see if radio-collared wolves were in proximity and, because she was a biologist as well as a caretaker on a ranch, she collected data.

DH But the image goes far beyond a representation of data collection. It looks like a spiritual act, as though she's summoning natural powers or participating in some kind of ritual.

LM Yes, she's wearing her nightgown, because she regularly did this early, and she raises this strange equipment to the sky. That's why

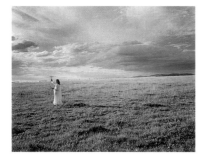

I wanted to make this picture: it doesn't look like science or cattle protection, but it is.

DH The elk population is also managed—permitted to reproduce enough to allow hunting. Your photographs of a flayed elk are magnificent, even ceremonial. In some ways, they're the most visceral images in the book, yet hunting may be the least invasive activity in terms of the impact on the ecology, compared to dams, mines, ranches, and so on.

LM Hunting is part of human culture. It was a revelation to me that some people really love to hunt, not for trophies, but for the food it provides. People choose to do it in order to remain connected to the land. I hoped to convey the power and beauty of this elk's death and its transformation into food. The color is very important here: the whitish blues of the snow, the bloodred of the meat.

DH The picture of the scene as a whole is baroque, reminiscent of the European tradition of paintings of hunting scenes or still lifes with carcasses. It's monumental.

LM It's a monumental act. Hunters are highly skilled. They make a commitment to being good at the hunt as well as cleaning animals. It's actually a beautiful experience to watch as someone works when you're around a hunter who is respectful of the animal and very accomplished.

DH What about the Valley's small human population? Your work includes people, either in the form of portraits or in the evidence of their activities.

LM Yes, each person can represent an aspect of the social and environmental web and they are all loosely connected: for instance, the Peruvian shepherd living in a covered wagon tending sheep barbecues lamb for the home-schooled girl who plays with the child of the landowners who are related to the irrigator who socializes with the fish biologists who occasionally employ the guy eking out his living panning for gold in the tailings of a mine, one that was originally searched by nineteenth-century miners and, later, the Chinese. That is what is so fantastic about such a small community. You can really see all the connections.

Quartered Rocky Mountain Elk
PAGE 47

Gamaniel Tacza, Peruvian Shepherd
PAGE 10

Mattie with a Bourbon Red Turkey
PAGE 9

There are no degrees of separation, but each person has a slightly different relationship to the environment of the Valley. Each represents a different set of answers to the question of the contested landscape.

DH In particular, portraits of Mattie punctuate the book's narrative. She's often emerging from blackness and appears on the cusp of adulthood. She is the central human character in this book, yet she's not an adult.

LM Mattie became central to this series as I worked. A young girl on the verge of adulthood, she had an extraordinary childhood, a life quite different from most children in the twenty-first century, maybe closer to children at the beginning of the twentieth century in many regards. She can hunt and fish; she can raise and kill a turkey and pluck it. She rides, and though her life was solitary when she was younger, it was richly imaginative. In the picture of Mattie holding her Thanksgiving Day turkey upside down with the wings spread out, she becomes for me a kind of inverted angel. I like my work to function metaphorically, yet with lots of attention to fact and detail. You can see every thread in her jacket and every feather on the bird.

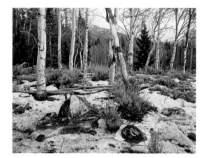 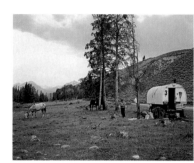

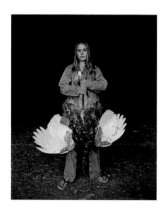

In the photographs, Mattie is both a twenty-first-century teenager and also an incarnation of my grandmother, a girl born at the dawn of the twentieth century who came of age in the West. She also represents her own generation, my daughter's generation: they are the inheritors of all the beauty and the predicaments described in this work.

DH These photographs relate to early photographic portraiture, just as some of your landscapes call to mind the explorations of Muybridge or Watkins. Why did you choose this format?

LM I was thinking about August Sander and Mike Disfarmer in particular. I was also thinking of paintings of standing females, such as Manet's portrait of Victorine Meurent with a parrot. I love photographic studio portraiture from around the world, especially pictures in which people have not been conditioned to smile for the camera as an automatic response. I loved the idea of the barn as a studio and the sun as lighting.

DH I've watched you make a photograph. I know it's a very physical, time-consuming process. I also understand that, in your final prints, retaining the integrity of the image you see in the ground glass is of the utmost importance to you. You don't alter or crop much.

LM I work with an 8 × 10 view camera, which is essentially a mahogany box on a tripod. I like that technology because it's very simple. It's a box with a lens on the front and a ground glass on the back. That's about it. Using nineteenth-century technology in the twenty-first, I feel as if I am able to slow time down and open space up, just through the process. And because of the size of the negative, you see an almost surreal level of detail.

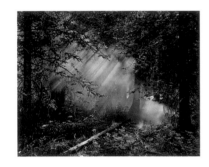

DH It transforms beholding.

LM I'm completely mesmerized by the idea of that kind of extended looking.

DH The journey you take viewers on was very differently presented in your recent exhibition at the Museum of Fine Arts, Boston, than in this book. The photographs were printed at 8 × 6 feet. At this huge size, they maintained extraordinary clarity. Why did you choose that size for the exhibition, and what did you hope for in terms of the viewer's experience?

LM I hoped that the size would draw the viewer into a vortex of color and form and darkness and light. The physicality of the experience drops you through a window—but also informs the way the light travels, or the way you perceive the needles on the branch of a fir tree, or the ferns and moss on the bank of a stream. In a book, you have a more intimate experience, and I think you can follow a narrative in a sustained way.

DH I think also that the scale of the exhibition prints suits the place depicted: the epic mythology of the West is here reconsidered and reimagined. In some ways, the most spectacular event pictured in this work is the forest fire. Would you talk about the fire, and the idea of loss that pervades those pictures?

LM The forest fire was for me the cataclysmic culmination of this work. In a big space you get big, dramatic events, at once natural and human-induced. As we know, fire is an inevitable part of nature's cycle in western forests. In the past, before the land was managed, forest fires would ignite, often lit by a bolt of lightning, and dead trees burned, leaving the land open and providing a diversity of habitat for animals and opportunities for the natural succession of plants. Now we suppress fire, but still, conflagrations occur, often when conditions are extreme.

DH How did this fire start?

LM A man who was spending his last day in the Valley before moving away was burning a cardboard box in a burn barrel. It was very dry, right around Labor Day. The wind was blowing and sparks escaped from the barrel. Imagine those moments as you begin to recognize the enormity of what is happening and the fact that there is nothing you can do about it. By the time I arrived, the valley was like a war zone, full of helicopters dangling buckets and planes dropping pink fire retardant. Every effort looked insignificant in the face of the power of that fire. Within a matter of days forty thousand acres had burned.

DH How did you achieve the intimacy and drama of *Understory Flareups*? I find it terrifying to enter a burning forest, yet, at the same time, it's a tranquil, comforting scene. After looking at this photograph for a while, I feel an overwhelming sense of tragedy.

LM I enlisted the aid of a woman in the Forest Service, who had an idea where it would be safe to stand, which allowed me to be very close to the fire, the sound of it and the experience of it, which I hope is visually translated in the photograph.

DH Why are the fire photographs the concluding suite of images?

LM In part it's a matter of chronology but more importantly I think those images reflect that we have constructed a world where we live in a perpetual state of cognitive dissonance. Any one of us can make mistakes like the man with the burn barrel. But we're good at convincing ourselves that the little allowances we make every day, the use of fossil fuels or chemicals in the kitchen or on the lawn, for instance, won't really make any difference.

INTERVIEW WITH LAURA McPHEE

But when there are enough chemicals or enough CO_2 in the atmosphere or enough dams or fuel on the ground in the form of dead trees, the implications of our actions, the unintended consequences, become clear. A process gets started and we are largely powerless to stop it. We're not even sure we want to. I don't think I understood all this so profoundly before I watched life, all kinds of life, unfold during the years I spent visiting the Valley.

DH These photographs draw attention to and disrupt the cognitive dissonance you describe; they allow us to see the physical, conceptual, and spiritual constructions we've overlaid onto the landscape—the ways we use it to tell ourselves often contradictory stories about who we are, what nature is.

LM I hope that viewers will understand the pictures as a way of talking about the veils and layers there are in life itself. Our decisions about each other, the land, animals. . . . I seek to portray the profound beauty of life and at the same time the deep darkness that can accompany that. In a mere couple of centuries the face of this land has changed radically. To return to my own personal narrative, the country my grandmother saw was already being defaced. It was already a world of mining. Now we are better at covering things up, at keeping things out of view. Much of the damage we are doing is invisible to the casual observer. The challenge for me was to make images that made our dilemmas visible. We all have a little piece of understanding but to really see the whole layered picture is just impossible. This is really the Achilles' heel of the human race: no one of us has the ability to truly synthesize all the elements, and, even if we could, no one else would agree with the analysis.

DH Yet you give us a glimpse, a chance for awareness.

LM Maybe we will learn to make different decisions, that's the thing we can hope for.

DH The three pictures that appear after this interview are more recent and form a coda for the book. The images are tragic yet they show signs of hope as well. Two years after the fire, and a year after the *River of No Return* work was first exhibited, you returned to photograph some of the burned areas. These photographs intertwine imagery of devastation and regeneration.

LM I revisited two canyons where the fire burned very hot. The resulting pictures are a meditation on ruin and loss but also on the possibilities that follow overwhelming change. They're aftermath images, but in their details you can see signs of the resurgence of life in all its beauty and intricacy. I find them reassuring.

121

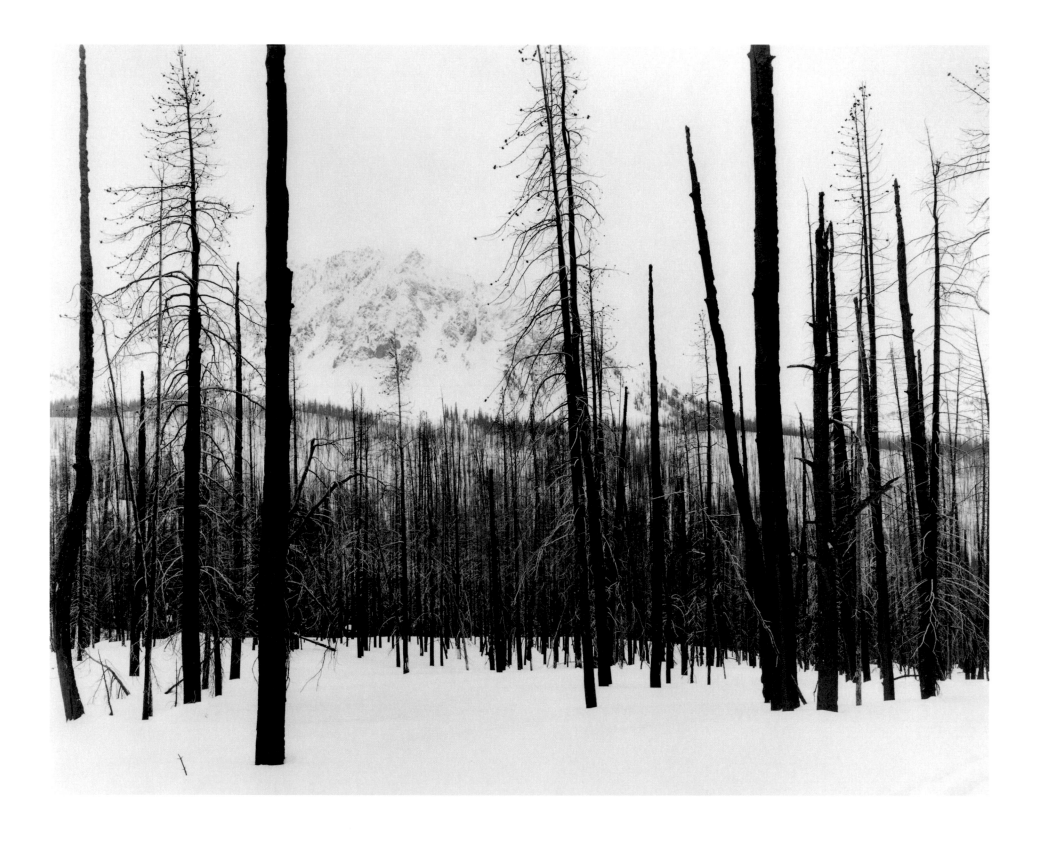

Washington Peak, White Cloud Mountains, Custer County, Idaho, 2008

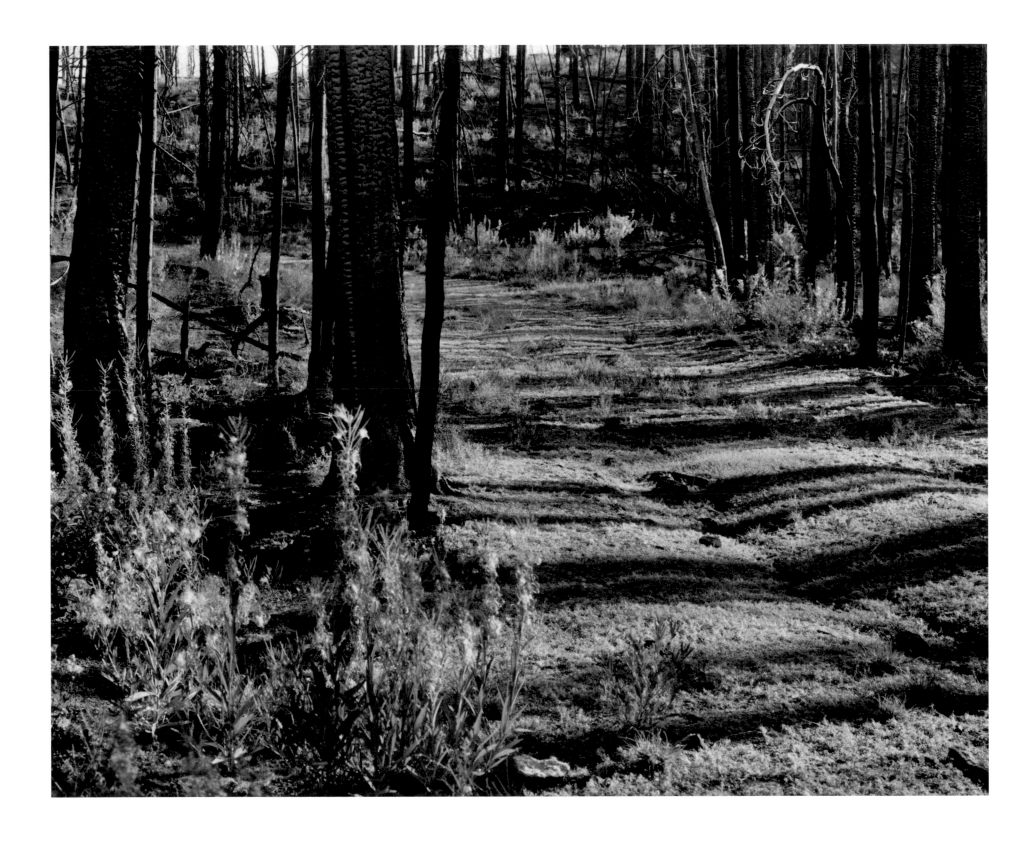

Regrowth, Closed Road near Aztec Mine, Custer County, Idaho, 2007

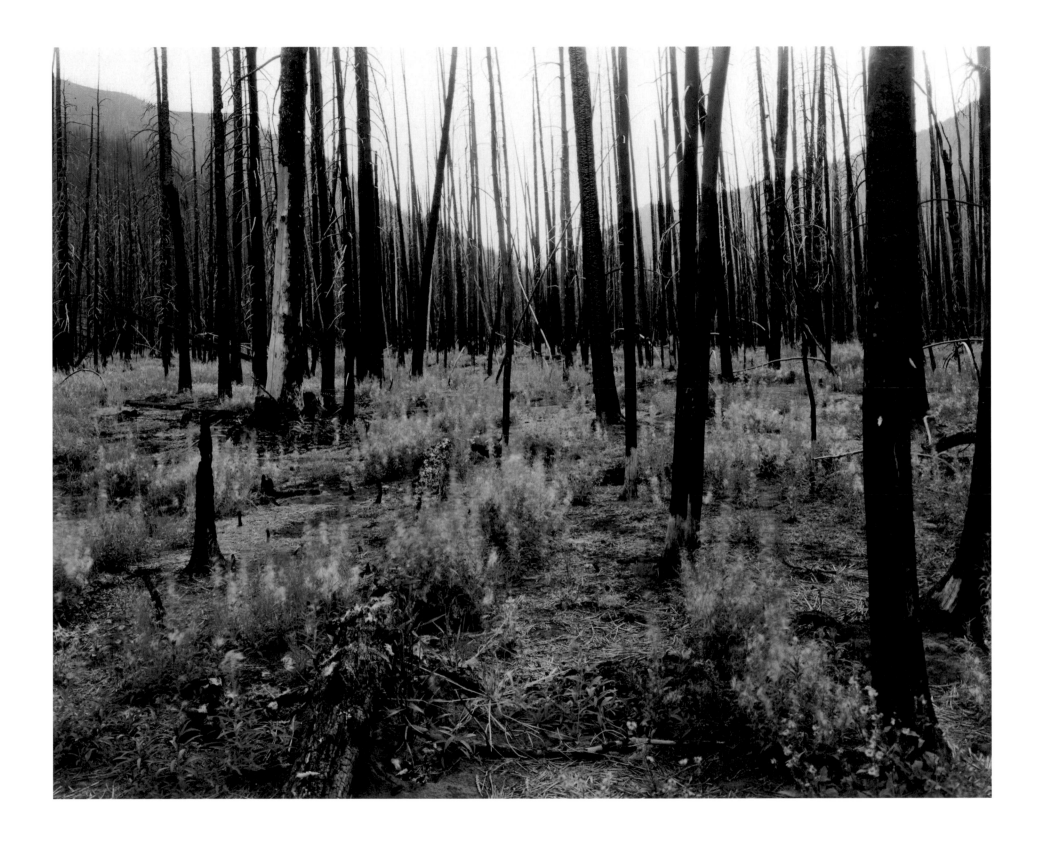

In Fourth of July Creek Canyon Looking West, Custer County, Idaho, 2007

Acknowledgments

Nothing would be on these pages without you: Candace, Michael, Bob, Mattie, Judy, Lucy. Words cannot express the feeling.

My boundless appreciation goes to the following (and to many who are unnamed) for your thoughts, your generosity, and your dedication:

Alturas Foundation

The writers who have contributed time and talent: Robert Hass, Joanne Lukitsh, Dabney Hailey

Yale University Press: Michelle Komie, Daphne Geismar, Mary Mayer, John Long, Daniella Berman, Jeff Schier

Museum of Fine Arts, Boston: William Stover, Cheryl Brutvan, Malcolm Rogers, Anne Havinga, Karen Haas, Cliff Ackley

Boise Art Museum: Sandy Harthorn, Terra Feast

Encouraging, compassionate gallerists and their staffs: Bernie Toale, Bonni Benrubi, Joseph Carroll, Rose Shoshana, Gail Gibson, Gail Severn

The one and only Color Services: Marc Elliott, Jim Ferguson, Barbara Compton, Nicole White, Jerry Miller, Wayne Boches, Paula Boswell, Adam Katseff, John Liz, Amy Essigmann, Beth Gilbert, Adam Lampton, Surendra Lawoti, Jacquie Strasburger, Elton Pope-Lance, Jon Doucette, John Hirsch

My patient, inimitable, unsurpassable helpers of all stripes: Anna Collette, Lily Brooks, Isobel McPhee, Dylan Vitone, Tricia French, Alane Brodrick, Judith Arons, Lucy Aptekar

All the good people of Stanley, Idaho, and environs. In particular: Bob Griswold, Mattie Griswold, Judy Hall, Jim Humphreys, Matt Humphreys, Marc Kottraba, Gamaniel Tacza, Donna Marie Hayes, Thad Gerheim, Tom Thurber, Mark Anderson, Bruce Bleak, Karen Scheidler, David Keiski, Craig and Betty Rember, Chris Flanigan, Isaac Babcock, Brent Snyder, Rob Trahant, Bonnie Hansen, Julie Meissner, Brian Reeves, Anna Paine, Pat Russell, Marilyn Mueller

My colleagues of two decades at the Massachusetts College of Art and my cherished friends, old and new

My teachers and my students and all those who walk beside me on this fascinating, uncertain, mysterious journey

My family: nuclear, genetic, extended, in-law, step, adopted, here and gone: infinitely expanding, all beloved. You enfold me.

Contributors

Dabney Hailey is the Linda Wyatt Gruber '66 Curator of Painting, Sculpture, and Photography at the Davis Museum and Cultural Center, Wellesley College. She curates contemporary photography exhibitions as well as the museum's permanent collections galleries.

Robert Hass was U.S. poet laureate from 1995 through 1997. His most recent collection of poems, *Time and Materials*, won the 2007 National Book Award and the 2008 Pulitzer Prize.

Joanne Lukitsh is professor of art history at the Massachusetts College of Art and Design. She is the author of *Julia Margaret Cameron* and other publications in the history of photography.

Laura McPhee is professor of photography at the Massachusetts College of Art and Design. Her books include *No Ordinary Land: Encounters in a Changing Environment* and *Girls: Ordinary Girls and Their Extraordinary Pursuits*.

Alturas Foundation is proud to have selected Laura McPhee as its initial Artist-in-Residence and to have sponsored her creation of the artworks comprising *River of No Return*. Additional support was provided for the first exhibition of these photographs in 2006 at the Museum of Fine Arts, Boston, and for the publication of this monograph.

Alturas Foundation, a family foundation representing four generations in the American West, is committed to the visual arts and American culture. The Alturas Residency Program encourages artists to explore fresh directions and provides opportunities to develop new ideas over extended periods.

LIBRARY OF CONGRESS CATALOGING-IN-PUBLICATION DATA
McPhee, Laura.
River of no return / photographs by Laura McPhee ; foreword by Robert Hass ; with an essay by Joanne Lukitsh and an interview with Dabney Hailey.
p. cm.
Includes bibliographical references.
ISBN 978-0-300-14100-9 (hardcover : alk. paper)
1. Photography—Idaho—Salmon River Valley. 2. Photography, Artistic. 3. Salmon River Valley (Idaho)—Pictorial works. 4. McPhee, Laura. I. Lukitsh, Joanne. II. Hailey, Dabney. III. Title.
TR25.S35M37 2008
779'.9551483097967—dc22
2008029185

A catalogue record for this book is available from the British Library.

This paper meets the requirements of ANSI / NISO Z 39.48-1992 (Permanence of Paper).

10 9 8 7 6 5 4 3 2 1

Designed by Daphne Geismar, www.daphnegeismar.com
Set in Celeste type by Daphne Geismar
Printed in Italy by Mondadori

Epigraph: Copyright © 1981 by Marilynne Robinson. Reprinted by permission of Farrar, Straus and Giroux and Curtis Brown, Ltd.

Page ii: *Irrigator's Tarp Directing Water, Fourth of July Creek Ranch, Custer County, Idaho, 2004*